LIVERPOOL LANDING STAGE
THROUGH TIME
Ian Collard

AMBERLEY PUBLISHING

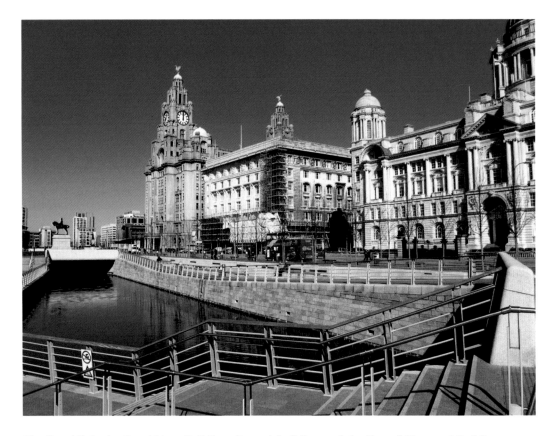

The Canal link, the Royal Liver Building, Cunard Building and the Port of Liverpool Building.

First published 2011

Amberley Publishing
The Hill, Stroud,
Gloucestershire, GL5 4EP

www.amberley-books.com

Copyright © Ian Collard, 2011

The right of Ian Collard to be identified as the
Author of this work has been asserted in accordance
with the Copyrights, Designs and Patents Act 1988.

ISBN 978 1 4456 0413 8

British Library Cataloguing in Publication Data.
A catalogue record for this book is available from
the British Library.

Typeset in 9.5pt on 12pt Celeste.
Typesetting by Amberley Publishing.
Printed in the UK.

Introduction

The Pier Head and landing stages have been places where the people of Liverpool have been able to view, participate and enjoy many of the major maritime celebrations and events of the last hundred years. It is the city's equivalent to the Sydney Opera House, Fisherman's Wharf at San Francisco, the Manhattan Piers in New York and the Tower Bridge in London. The Liverpool Maritime Mercantile City is a UNESCO designated World Heritage Site, which comprises of the Pier Head, Albert Dock and William Brown Street. The World Heritage Committee, in 2004, stated that it was 'the supreme example of a commercial port at the time of Britain's greatest global influence'.

The landing stages were constructed around 1850, and the northern section was known as Princes Landing Stage, with Riverside Station located on Princes Parade. The station opened in 1895 to enable passengers from the steamers to get to their destinations more quickly and easily than having to be transported to the other major railway stations in the city. In 1876, George's Stage, used by the ferries, was joined with Princes Stage and extended. It was 2,534 feet long by 80 feet wide, and carried approximately 200 pontoons. There were ten bridges connecting with the shore, and the floating roadway gave access to private and commercial vehicles. Both stages were scrapped in the 1975/76, when the passenger liners finished operating from Liverpool, and a new stage for the Mersey ferries and the Isle of Man Steam Packet was constructed, opening in 1975. However, the south stage, which was used by the ferries to Woodside and Seacombe, sank in 2006, and was broken up. A new landing stage for the Mersey ferries has been ordered to replace the temporary structure that has been used up to 2011, when the ferries operated from the Cruise Facility landing stage.

The water was run out of George's Dock in 1900, and Sir Arnold Thornley and F. B. Hobbs were given the job of designing a headquarters building for the Mersey Docks & Harbour Board. Work on the 'dock offices' began in 1904 and the building was completed in 1907 at a cost of £350,000. It was built with a reinforced concrete frame, clad in Portland stone, and was designed in Edwardian Baroque style, with a large dome on top.

The fact that it was built using reinforced concrete meant that it was not only structurally strong but also more fire-resistant than other buildings. As it was built on the site of the old dock, it also required deeper-than-normal foundations, and over 35,000 tons of cement was used. Also, as it was built next to the river, asphalt was used to coat the floors and walls of

the basement to ensure that it was waterproof. It is built with mahogany from Spain and oak from Danzig, with bronze for the floor furniture and fittings and white marble for the floors and walls. The grey granite grand staircase is lined with stained-glass windows with images of Poseidon. There is a globe at the entrance, supported by dolphins and the cast iron gates are decorated with mermaids, anchors and shells.

During the May Blitz of 1941, a bomb exploded in the basement on the eastern side, causing extensive damage to the building. However, the rest of the building was soon in use and the damage was repaired at the end of the war. It was the headquarters of the Board for eighty-seven years, from 1907 to 1994, when the company relocated to smaller offices at Seaforth Dock, near the main container berths. The building was sold to a property developer, and between 2006 and 2009, over £10 million was spent on restoring most of its original features.

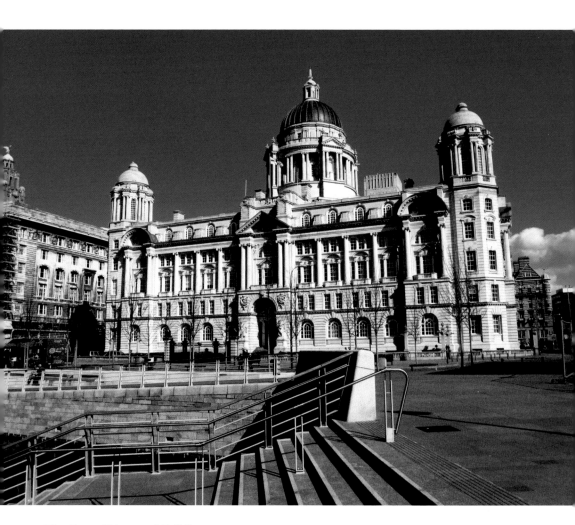

The Port of Liverpool Building.

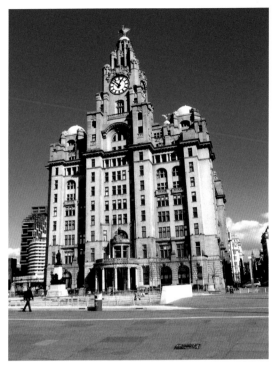

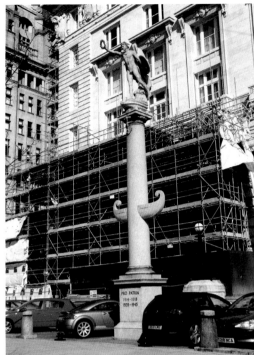

The Royal Liver Building. The Cunard War Memorial.

As there were over 6,000 employees in the Royal Liver Group in 1907 the company felt that they needed larger premises and approval was given for the construction of the Royal Liver Building at the Pier Head, near to the recently constructed Port of Liverpool Building. It was designed by Walter Aubrey Thomas and the foundation stone was laid on 11 May 1908. The building was officially opened by Lord Sheffield on 19 July 1911 and was also constructed using reinforced concrete.

The building incorporates two clock towers, with clock faces of 25 feet in diameter, which are larger than those on Big Ben, in London, and were the largest electronically driven clocks in Britain. The clocks were originally called 'George' clocks, as they were started at the exact time that King George V was crowned on 22 June 1911. Electronic chimes were added in 1953. The Liver Birds, designed by Carl Bernard Bartels, stand at the top of each tower, with one bird looking over the City and the other facing the river. Legend says that if one of the birds were to fly away then Liverpool would cease to exist. The Royal Liver Building is reputed to be the inspiration for the Manhattan Municipal Building in New York, and the Seven Sisters in Moscow.

The Cunard Building, constructed between 1914 and 1917, was designed by William Edward Willink and Philip Coldwell Thicknesse. It is a mixture of Italian Renaissance style and Greek Revival, and was inspired by the grand palaces of Renaissance Italy. It was built by Holland, Hannen & Cubitts with Arthur J. Davis, of Mewes & Davis, acting as consultant. The building was the headquarters of the Cunard Line, which in 1934 became the Cunard White Star Line. It incorporated a large booking hall on the ground floor, with models of some of the passenger liners that had been conceived, designed and planned in the building, such as the *Queen Mary* and *Queen Elizabeth*.

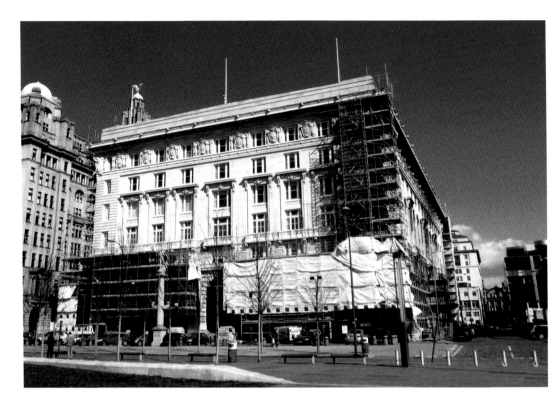

The Cunard Building.
Incorporated in the building was space for waiting rooms for first, second and third class passengers, luggage storage rooms and a currency exchange. The basement became an air-raid shelter during the Second World War, and was the central Air Raid Precautions headquarters for the City of Liverpool. However, the building ceased to be the headquarters for the Cunard Line when they relocated to Southampton in the 1960s, and it was sold to the Prudential Insurance Company in 1969, then to the Merseyside Pension Fund in 2001.

The Cunard War Memorial is located on the river side of the building, and was erected in memory of Cunard employees who lost their lives during both World Wars. It is a Grade I listed monument, designed by Arthur Davis, erected in 1920 and unveiled by the Ear of Derby, Edward Stanley, in 1921. It consists of a bronze statue sitting on top of a Doric style column, sculpted by Henry Pagem, with John Stubbs & Sons responsible for the stonework. The figure of a man standing on the prow of a ship was designed to represent victory. The inscription reads 'pro patria', which means, 'for one's country'. There are also a number of other memorials at the Pier head, the Merchant Navy war memorial, the Memorial to the Heroes of the marine engine room, the Alfred Jones memorial, the Monument of Edward VII, the Johnnie Walker and the memorial remembering all the Chinese merchant seamen who served and died in both World Wars.

The Leeds & Liverpool Canal is now linked to the south dock system by a new section, built across the Pier Head in a £22 million project. Funding for the work came from the North West Regional Development Association, and also from the European Objective 1 programme. The work was completed in 2009. The Canal runs down to Stanley Dock and the docks between Salisbury Dock and Princes Half Tide Dock had been filled in with just a small channel remaining. Consequently, a channel had to be dredged through those docks as well as Trafalgar and West Waterloo Docks. A new fixed bridge and lock were built at Princes Dock, and a culvert was built beneath St Nicholas Place and the entrance road to Princes Parade. The canal link then crosses in front of the Royal Liver Building, the Cunard and Port of Liverpool Buildings, and terminates at Canning Dock.

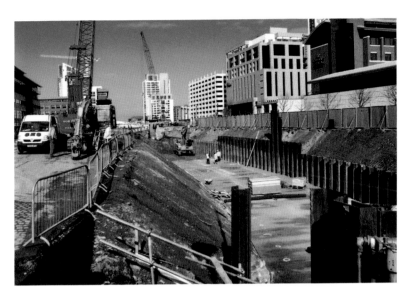

Construction of the Canal link at Princes Dock.

In 2007, work started on the construction of the new Museum of Liverpool Life which opens in July 2011. The museum will demonstrate Liverpool's unique contribution to the world and showcase popular culture while including social, historical and contemporary issues. The content of the Museum will be structured into four core themes: the Great Port, Global City, People's Republic and the Wondrous Place, located in four large gallery spaces. The ground floor will look at the urban and technological evolution of the city and the impacts of national developments such as the Industrial Revolution, the British Empire and the consequential economic impact upon the city's development. The upper floors will show the social history of the city up to the present day and analyse migration, the growth of communities and the diversity of culture, which give Liverpool its strong identity.

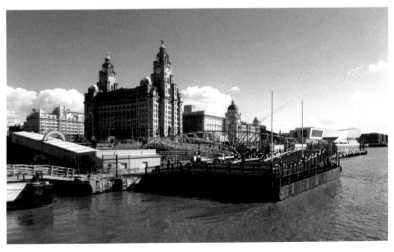

The Pier Head and landing stages, with the Museum of Liverpool nearing completion in March 2011.

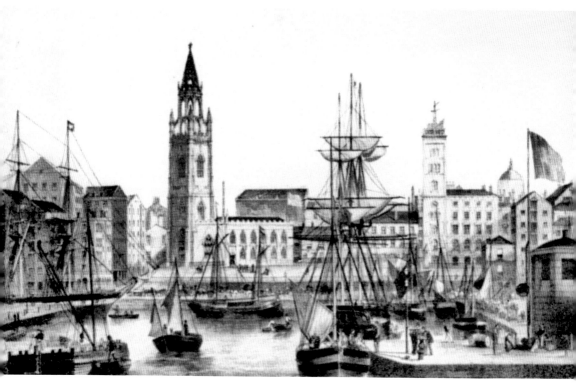

Sailing ships loading cargo in George's Dock, which was opened in 1771. The Dock, together with the adjoining George's Basin, was filled in, creating the Pier Head. The church of Our Lady and St. Nicholas is frequently referred to as 'the sailor's church'. St Mary del Quay was a small place of worship that was built on the site in the middle of the thirteenth century, until a new chapel was built nearly one hundred years later. This was dedicated to St Mary and St Nicholas, and when a plague hit the town in 1361, it was licensed as a burial ground. The chapel was extended in the fifteenth century, and by 1515 the church contained four chantry altars. The church was used to detain prisoners during the Civil War years, and between 1673 and 1718 the building was extended, with a spire was added in 1746. At the beginning of the eighteenth century, when Liverpool became an independent parish, St Nicholas and St Peter's became the parish churches. The church was extended again in 1775. On 11 February 1810, twenty-five people were killed, including seventeen young girls from the Mossfield's Charity School, when the spire of the church collapsed. A new tower, designed by Thomas Harrison of Chester, was built between 1811 and 1815. The last burials in the graveyard took place in 1849, after which it became a public garden, dedicated to James Harrison, whose shipping line office was situated to the rear of the church. A Deed of Faculty was granted in 1892 to allow the laying out of the graveyard as an ornamental ground, and a Parish Centre was built in the 1920s. The church was severely damaged in the Blitz of December 1940, and following extensive rebuilding, it was re-consecrated on 18 October 1952.

Opposite below: The floating roadway was built to allow vehicles onto the landing stage.

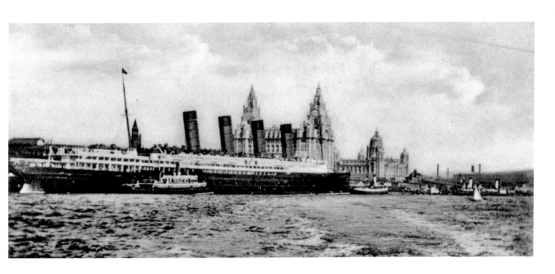

The Cunard liner *Lusitania* and the Mersey ferries at the landing stage. *Lusitania* was built by John Brown & Co. on the River Clyde, and sailed her maiden voyage from Liverpool to New York on 7 September 1907. The following month, *Lusitania* gained the Blue Riband of the Atlantic, with an average speed of 23.99 knots between Queenstown and Ambrose Light. On 1 May 1915, the German Embassy in Washington published a notice in a New York newspaper reminding passengers of the dangers of travelling by sea on Allied ships. *Lusitania* left New York later that day, with 1,959 people on board, and just off the Old Head of Kinsale, she was torpedoed by the German submarine *U 20*. *Lusitania* soon developed a list and sank twenty minutes later. It was later reported that *Lusitania* carried 4,343 cases of ammunition in her cargo hold. The German submarine captain was adamant that he only fired one torpedo at the ship but a second explosion was reported by survivors, and this may have been caused by the cargo of ammunition.

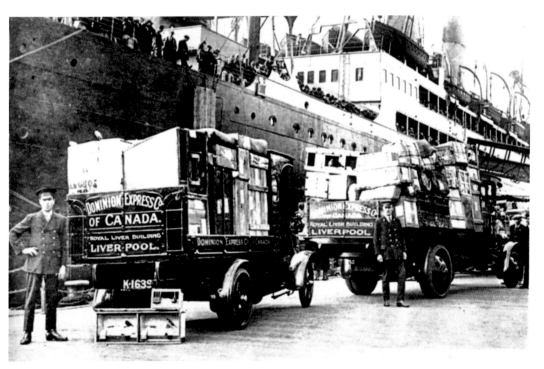

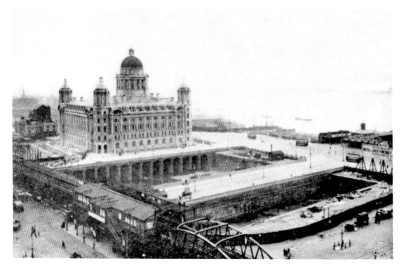

The Mersey Docks
& Harbour Board
building prior to
the completion
of the Cunard
and Royal Liver
Buildings.

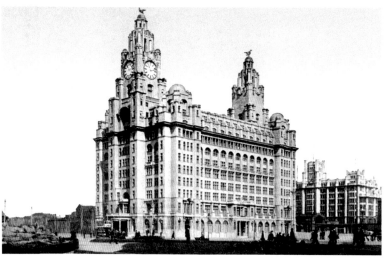

The Royal Liver
Building, following
completion in 1911.

Opposite above: Trams pass a line of horse-drawn taxi cabs, as they wait for passengers to embark from a passenger liner that had just arrived from New York. The building with the tower is Tower Building, which was completed in 1908, designed by W. Aubrey Thomas, and is one of the earliest steel-framed buildings built in the United Kingdom. It is finished with self-cleaning, white-glazed tiles and large windows to allow the maximum amount of light into the building. Sir John Stanley built the first Tower in 1406, and during the eighteenth century the Tower of Liverpool, between Tower gardens and Stringers Alley, was the main jail of Liverpool. It was used to house debtors and criminals. The Tower contained seven small, underground dungeons, which housed three to five prisoners each, and there was a chapel in one of the rooms. In 1756, during the war with France, the Tower was used to house prisoners of that conflict. It became the property of the Corporation in 1775, when they purchased it from Sir Richard Clayton. On 3 July 1811, all prisoners were transferred to a new jail in Great Howard Street. The Tower was demolished in 1819, replaced by warehouses, and by 1856 a second Tower Building, containing offices, was built on the site. This building was demolished only fifty years later. Tower Building was converted into apartments in 2006, with the two lower floors retained for commercial and retail use. It overlooks the Royal Liver Building, built in 1910, which was also designed by W. Aubrey Thomas.

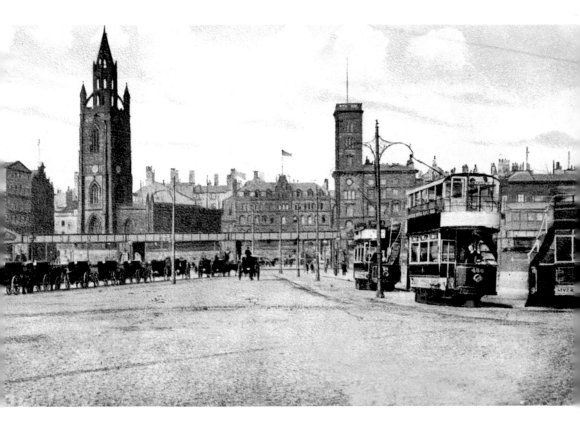

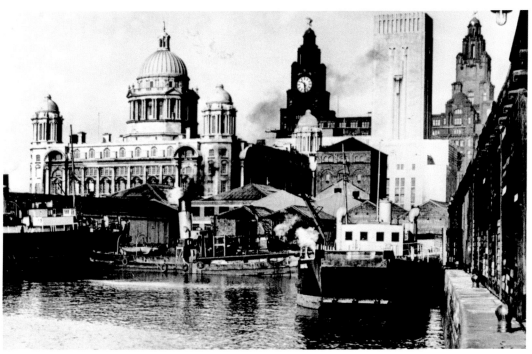

Landfall in Salthouse Dock.

Passengers embark onto the 'American Special Riverside Station to Euston (London)' train at Riverside Station on Princes Parade.

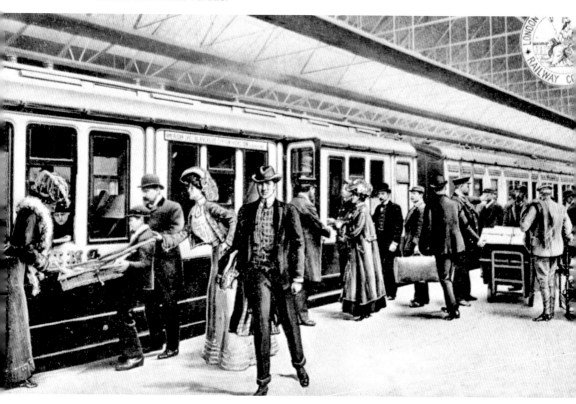

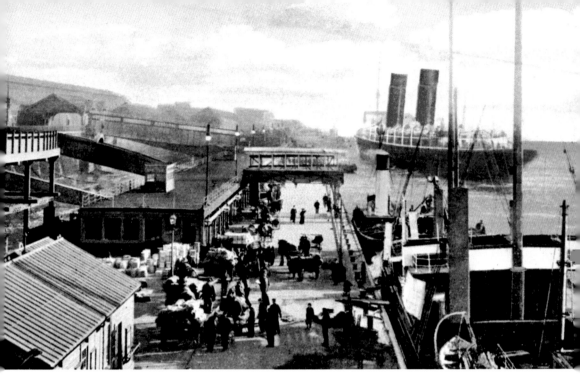

A Cunard liner, either *Campania* or *Lucania*, berths at the south end of Princes Landing Stage as passengers' luggage is loaded onto another liner.

Horse-drawn coaches await passengers from a berthed White Star liner at Riverside Station.

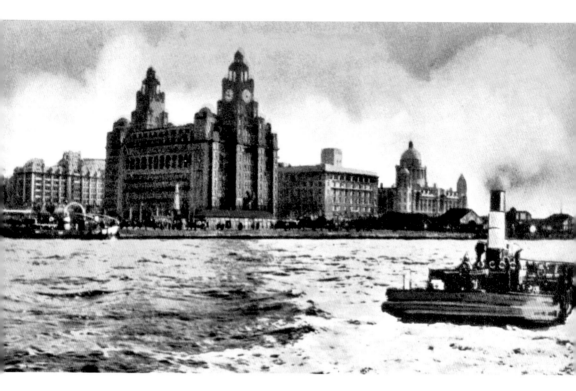

The Mersey ferries.

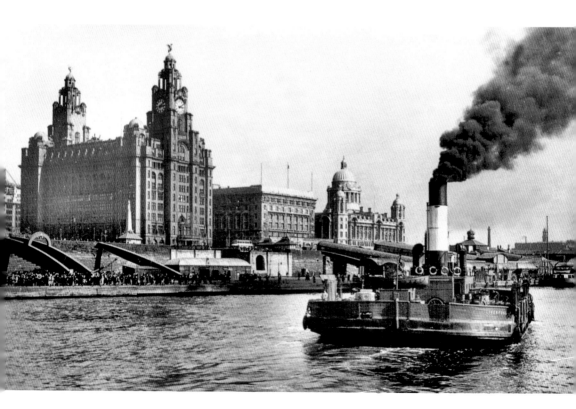

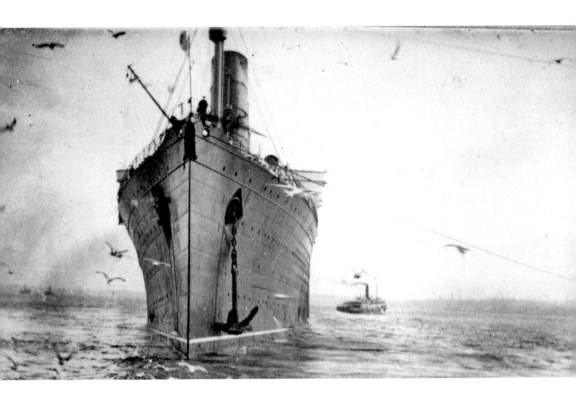

The Cunard liner *Lusitania* approaches Princes Landing Stage in 1910. The Royal Liver Building neared completion at about this time.

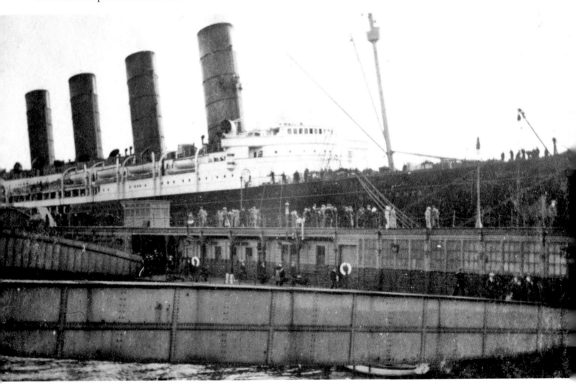

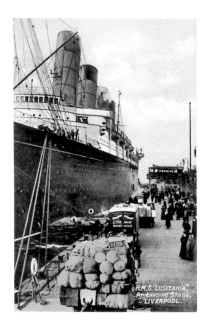

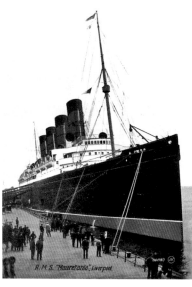

Busy scenes on the landing stage, as vehicles with cargo and passengers' luggage wait to be loaded onto *Lusitania* (left) and *Mauretania* (right).

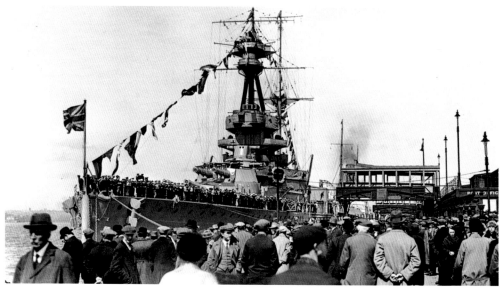

HMS *Ramillies* is open to the public at the landing stage. She was a Revenge class battleship, and served in both the First and Second World Wars. She was launched on 12 June 1913, at Dalmuir, Scotland, and was not commissioned until September 1917, as her rudder was damaged during her launch, and she was towed to Cammell Laird at Birkenhead for repairs. On commission, she joined the 1st Battle Squadron of the Grand Fleet, and served during the disturbances between Turkey and Britain in 1920. She joined the 2nd Battle Squadron of the British Atlantic Fleet in 1924, and during the General Strike in 1926 she was sent to the Mersey to land food supplies and was later transferred to Mediterranean duties. In the Second World War, she carried out convoy escort and served in the Mediterranean, the North Atlantic and the Indian Ocean. She provided fire support for the Normandy landings, and was placed in reserve on 31 January 1945, used as an accommodation ship at Portsmouth. She was sold and broken up in 1949, and one of her 15-inch guns has been preserved at the Imperial War Museum in London.

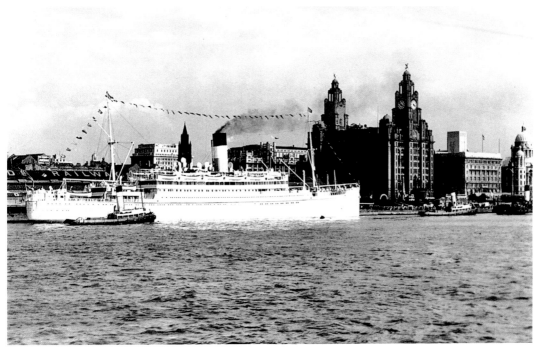

The Lamport & Holt passenger liner
Vandyck sails on a cruise from Liverpool.
She was built in 1921, designed for the
Liverpool to Brazil and River Plate service.
She entered service on the New York–River
Plate service, and made one voyage for the
Royal Mail Line in 1922. In 1932, she was
laid up at Southampton, and the following
year she was converted for cruising, her
hull painted white. She became an armed
boarding vessel in 1939, becoming HMS
Vandyck. In February 1940, she sailed
on one voyage to Halifax, Nova Scotia,
and was then sent to Scapa Flow as an
accommodation ship and later a depot ship.
She took part in the Norwegian campaign
that year, and was damaged by the *Admiral
Hipper,* then was set on fire by German
aircraft off Harstad, near Narvik, on 10 June
1940. She was abandoned, and her crew
captured when they reached land. She sank
the next day, following further attacks by
German aircraft.

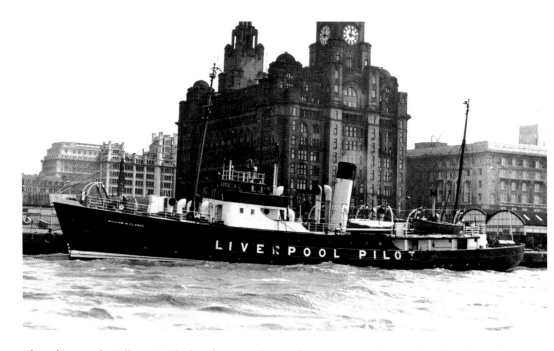

The pilot vessel, *William M Clarke* takes on pilots and provisions at Princes Landing Stage. She was built in 1937, and operated on the Mersey and in Liverpool Bay until 1962, when she was replaced by shore-based launches that tender the pilots to the Bar. *William M Clarke* was sold for service in the Humber, the *Sir Thomas Brocklebank* was withdrawn in 1974 and the *Edmund Gardner* and *Arnet Robinson* lasted until 1982, when they were withdrawn.

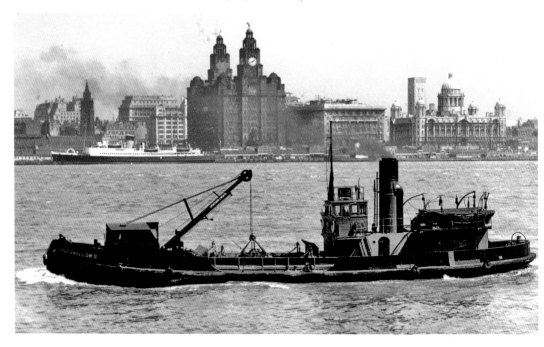

The dredger *Sand Swallow 11* passes the Isle of Man Steam Packet vessel *Mona's Queen*, which is berthed at the south end of Princes Landing Stage.

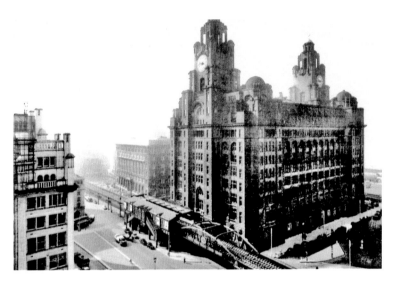

The Liverpool Overhead Railway Station, at the rear of the Royal Liver Building. The Railway was the world's first electrically operated overhead railway, and ran from Dingle to Seaforth, along the Dock Road. It was opened 4 February 1893, by the Marquis of Salisbury, and ran for six miles from Alexandra Dock to Herculaneum, with eleven stations along the line. It was extended to Seaforth Sands on 30 April 1894 and to Dingle on 21 December 1896. A northward extension was completed in 1905, which took the line to the tracks to the Lancashire & Yorkshire Railway's North Mersey Branch, allowing a service to be provided to Aintree Racecourse when the Grand National Race took place. Following the end of the War, various surveys were carried out, which found that the track and structure were badly corroded, and that it would be very expensive to repair the system. Consequently, the Liverpool Overhead Railway Company went into voluntary liquidation, and the line closed 30 December 1956. Work to completely demolish the line commenced in 1957 and was completed the following year.

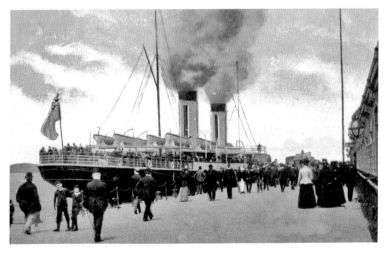

A passenger ferry prepares to sail from the landing stage.

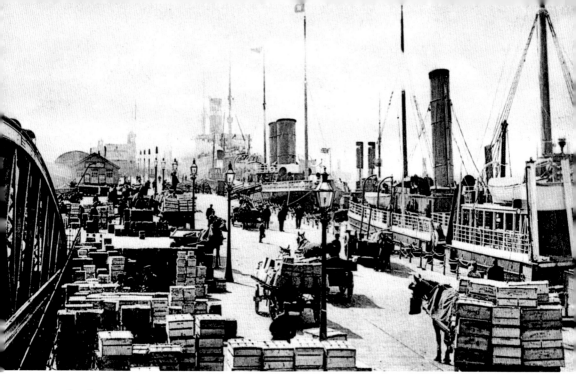

Isle of Man and Irish ferries are loaded with goods at the north end of the landing stage.

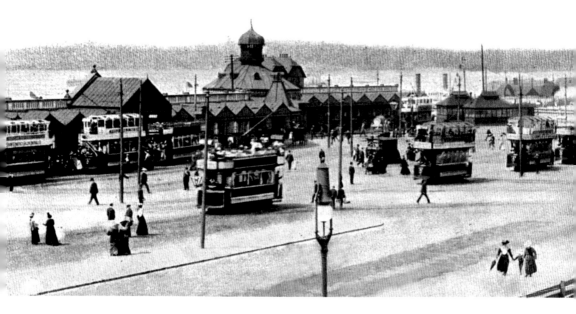

Passengers queue for trams in front of the Royal Liver Building.

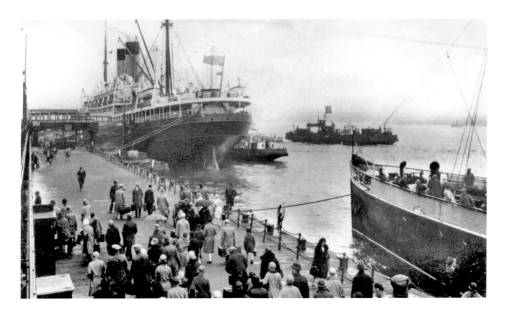

Crowds disembark a steamer from the Isle of Man, as a liner loads passengers for a transatlantic voyage to New York.

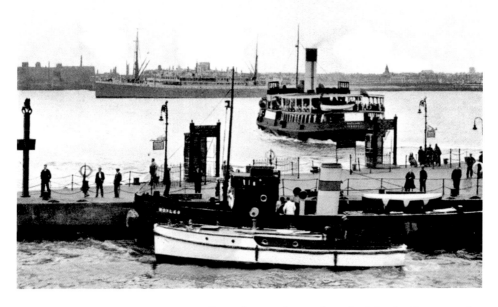

The Wallasey Corporation ferry, *Wallasey*, leaves the south end of the landing stage for Seacombe and passes the Elder Dempster liner *Apapa*, anchored in the river. *Apapa* was built by Harland & Wolff, at Belfast, and was launched in 1926. She was built for the British & African Steam Navigation Company and transferred to Elder Dempster in 1933. In June 1940, she rescued groups of Czech and Polish Air Force personnel from the Gironde River, near Bordeaux, and on a voyage from Freetown to Liverpool, she was bombed by a German aircraft on 15 November that year. The second bomb destroyed the engines, and a cargo of palm oil caught fire. There were 261 people aboard. twenty-four lost their lives and many were saved by the *Mary Kingsley*, which came alongside.

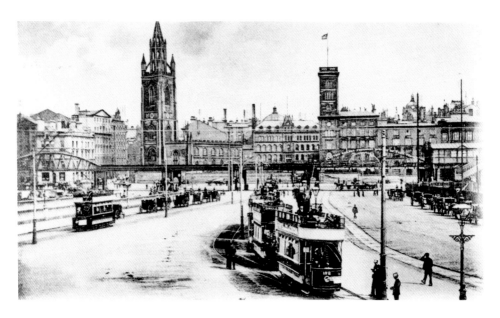

The No. 172 tram arrives at the Pier Head from Dingle, passing the Overhead Railway Station. The sign over the railway station states, 'Electric Railway, Frequent Services of Fast Trains to Seaforth, Waterloo and Gt. Crosby'.

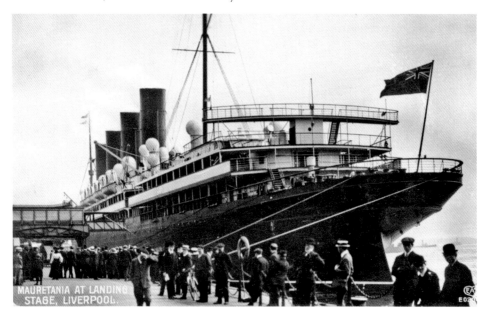

MAURETANIA AT LANDING STAGE, LIVERPOOL.

The Cunard passenger liner *Mauretania* readies to sail from Princes Landing Stage. *Mauretania* was built by Swan, Hunter & Wigham Richardson, at Wallsend, and sailed on her maiden voyage from Liverpool to New York on 16 November 1907. On 11 July 1913, she was present at the opening of Gladstone Dock, by King George V and Queen Mary. Later that year, she was the first Cunarder to be overhauled at Gladstone graving dock. She served as a troop transport and hospital ship during the First World War, and resumed service on the Liverpool to New York route on 28 June, 1919. Her hull was painted white for cruising in 1930, and was sold in 1935 for scrapping by Metal Industries at Rosyth.

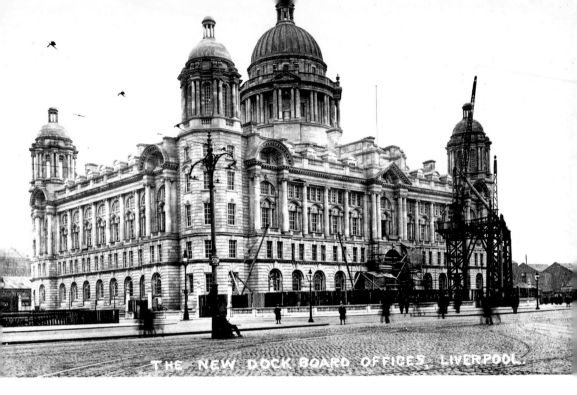

A photograph of the 'new' Dock Board offices at the Pier Head.

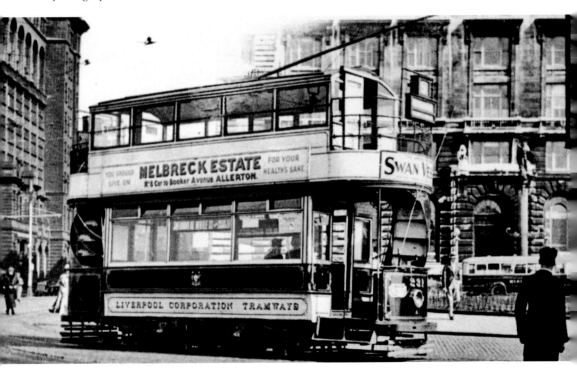

Liverpool Corporation Tramways vehicle No. 231, in front of the Cunard Building at the Pier Head.

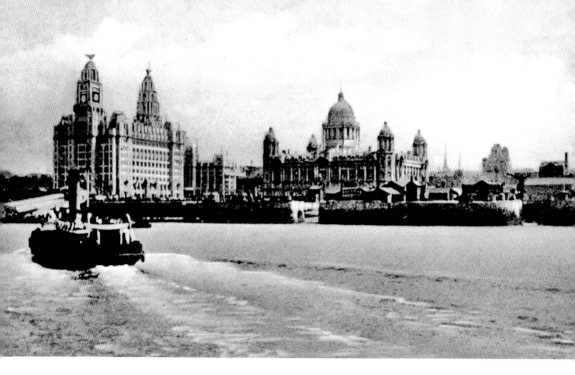

The Birkenhead Corporation ferry from Woodside heads towards the landing stage prior to the construction of the Cunard Building.

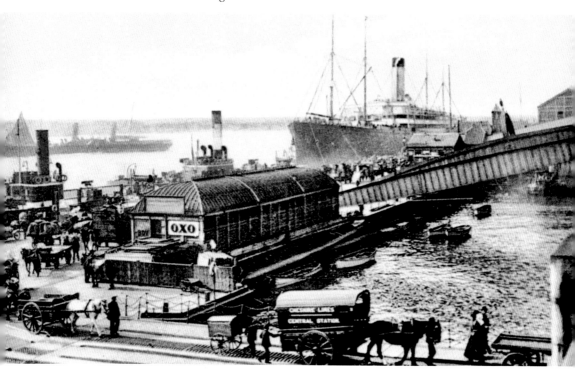

Two workers assist a horse pulling a vehicle from Cheshire Lines' Central Station off the landing stage, and up the floating roadway.

The Liverpool
Overhead Railway
station, at the Pier
Head, opposite
St Nicholas Church.

A ferry from New
Brighton passes an
excursion steamer
heading for North
Wales.

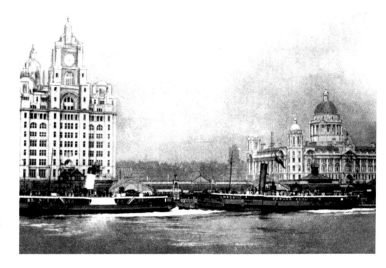

Mersey ferries
arrive at Liverpool
from Seacombe and
Woodside, prior to the
building of the Cunard
headquarters at the
Pier Head.

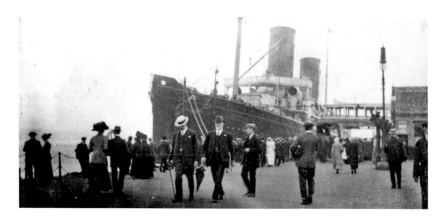

The Cunard passenger liner *Campania*, berthed opposite the Landing Stage Post Office, in 1907. She was built on the River Clyde by the Fairfield Ship Building Company, and sailed on her maiden voyage from Liverpool to New York on 22 April 1893. She took the Blue Riband of the Atlantic on her second crossing, and in 1894, she made her fastest crossing in 5 days, 9 hours, 21 minutes, at an average speed of 21.59 knots. *Campania* took part in the Diamond Jubilee Spithead Review on 26 July 1897. After completing her 250th voyage, she was chartered to the Anchor Line for 5 sailings, and replaced *Aquitania* when she was required for trooping duties. On the return of *Aquitania*, *Campania* was sold to Thos W. Ward for scrapping. However, she was acquired by the Admiralty for use as an Armed Merchant Cruiser and converted to that role by Cammell Laird at Birkenhead. Her foremast was removed, and a flight platform with a hanger was added during the conversion in 1915. She later returned to Birkenhead, where further work was completed for her to carry out her duties. On 5 November 1918, she broke from her moorings during a gale in the Firth of Forth, collided with the battleship HMS. *Revenge*, and sank.

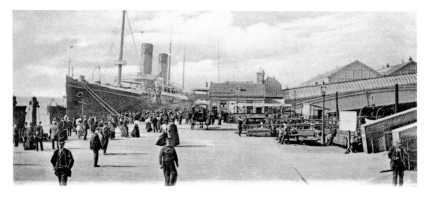

The White Star liner *Majestic* at the landing stage. She was built by Harland & Wolff, at Belfast, and sailed on her maiden voyage from Liverpool to New York on 2 April 1890. *Majestic* took the Blue Riband the following year, but lost it less than a month later to her sister *Teutonic*. In 1900, she was chartered by the Admiralty and carried out two voyages to Cape Town during the Boer War. A major overhaul was completed in 1902, and she returned to the Liverpool to New York service the following year. *Majestic* was laid up in 1911, but returned to service the next year, following the loss of the *Titanic*. She was sold to Thos W. Ward for breaking up at Morecambe, where she arrived on 10 May 1914.

The Wallasey
ferry *Rose* berths
at the landing
stage. She was
built in 1900 and
was a twin screw
vessel of 514
gross tons.

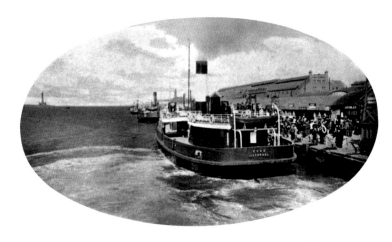

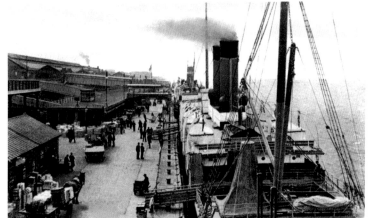

Goods and cargo are
loaded onto vessels at
Princes Landing Stage.

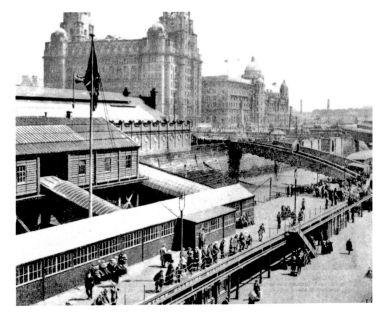

*Right and following
page top:* Relatives and
friends gather to say
farewell to passengers
sailing on liners from
the landing stage.

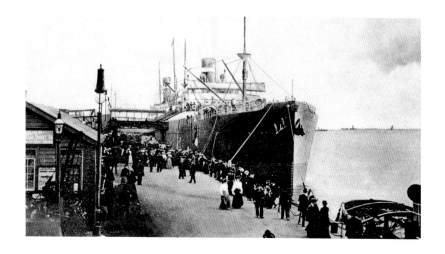

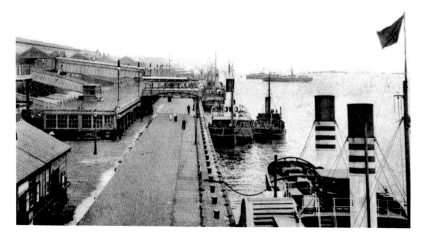

Tugs laid up at the landing stage at low water, waiting to receive their duties for the day.

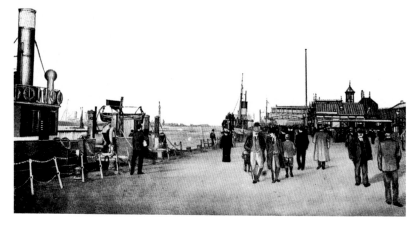

A Sunday afternoon stroll down the landing stage, before taking a ferry to Birkenhead or Wallasey.

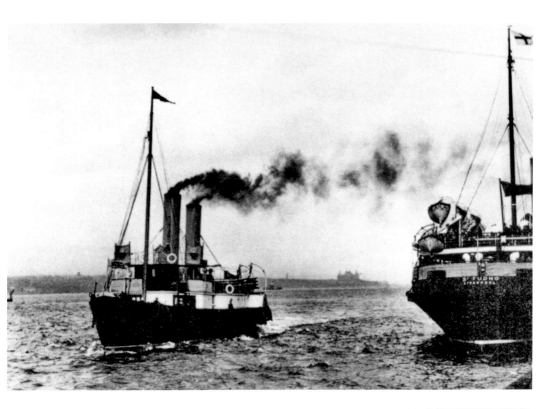

The Liverpool & North Wales Steamship Company operated passenger sailings to Llandudno and Menai Bridge, North Wales, from Princes Landing Stage. *St Elvies* is shown passing the larger *St Tudno* off the landing stage. *St. Elvies* was built by the Fairfield Ship Building Company on the Clyde, and was delivered in 1896. She was employed mainly on cruises from Liverpool and Llandudno around Anglesey, between Llandudno and the Isle of Man, and on day trips from Liverpool to Llandudno. She had new boilers and new funnels fitted in 1914, and carried out minesweeping duties during the First World War. *St Elvies* returned to service in 1919, was sold in 1930 and broken up at Birkenhead. *St Tudno* was also built by Fairfield's and replaced *La Marguerite* on the Liverpool to Llandudno and Menai Bridge service. *St Tudno* continued in service, apart from the war years, providing summer sailings to North Wales, until the company went into voluntary liquidation in 1962. She made her last sailing on 16 September that year, and was later sold and broken up.

Liverpool and North Wales

STEAMSHIP SAILINGS
Easter Sailings, Good Friday to Easter Monday.
Daily Sailings—Whitsuntide to September.
Weather and other circumstances permitting and subject to condition of carriage

Turbine Steamer "St. TUDNO" or "St. SEIRIOL"
Leaves Liverpool 10-45 a.m. for Llandudno (4 hours ashore) and Menai Bridge (1 hour ashore) due back 7-30 p.m.

Bangor or Beaumaris passengers with Single or Period Tickets proceed from Menai Bridge Post Office Square (Free Bus conveyance).

Fares.		Single		Day.	Period.
		1st.	2nd.		
Liverpool to Llandudno	6/6	5/-	*6/6	*8/6
,, Menai Bridge	8/-	6/6	*8/6	*10/6

* 1st class 2/- extra.
Half Day Sailings Certain Wednesdays, Saturdays and Sundays, Llandudno 4/6. 1st class 5/6.
Through Bookings from Principal Railway Stations, also Interchange Rail and Boat Tickets.
Special Boat Fares for Parties of 8 or more, including Free Pass for Promoter of Parties exceeding 25 in number.

Frequent Day Trips from Liverpool
Round the Island of Anglesey - 170 miles sail—See bills.
Daily from Llandudno at 1-15 p.m. to Menai Bridge and on certain Tuesdays to Douglas, Isle of Man, also frequent Excursions Round the Island of Anglesey (*see bills*) Morning, Afternoon and Evening Sea Cruises, and occasional Day Trips to Caernarvon and Amlwch by Motor Vessel " St. Silio."
Excellent Catering, Buffets and Refreshment Bars.
Contracts from 21/- Official Guide 2d. post free.

For Conditions of Carriage and all further particulars apply to—
The LIVERPOOL & NORTH WALES S/S Co. Ltd., 40 Chapel St., LIVERPOOL
Tel. No. 1653 Central.

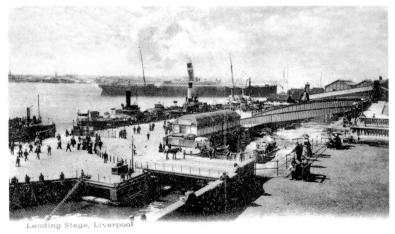

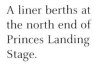

A liner berths at the north end of Princes Landing Stage.

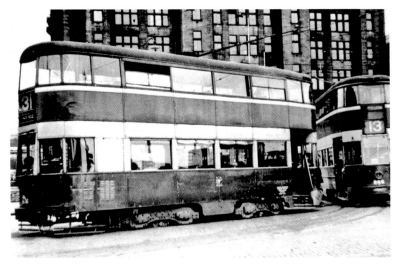

Liverpool Corporation trams, Nos 816 and 866, arriving at the Pier Head in front of the Royal Liver Building in 1947. Tram No. 866 is operating the 13 route to Edge Lane.

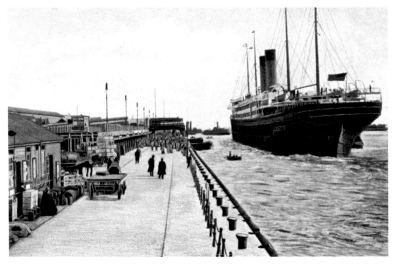

A White Star liner moves slowly onto her berth at the south of the landing stage.

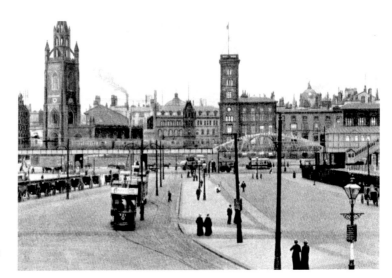

A train on the Overhead Railway heads north, as a line of empty horse-drawn taxis wait for business at the Pier Head.

The Birkenhead Corporation ferry *Claughton* berths at the landing stage. *Claughton* was built in 1876, by D. & W. Henderson & Company, at Glasgow, and was a sister of Birkenhead. In 1894, she was taken in part-exchange for *Birkenhead* (3) to the Liverpool Steam Towing Company as the tug *Australia*.

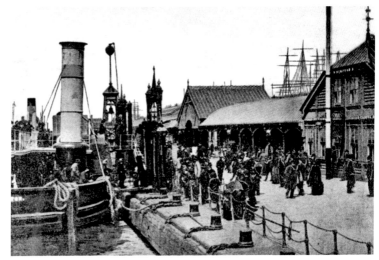

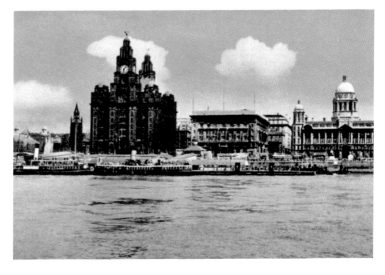

Birkenhead and Wallasey Corporation ferries at the Pier Head.

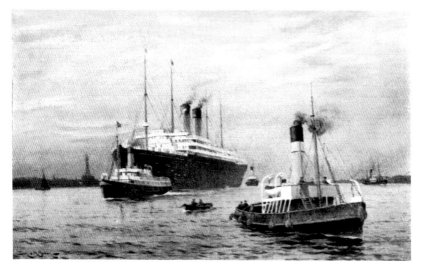

Tugs of the Alexandra Towing Company assist a White Star liner to berth at Princes Landing Stage.

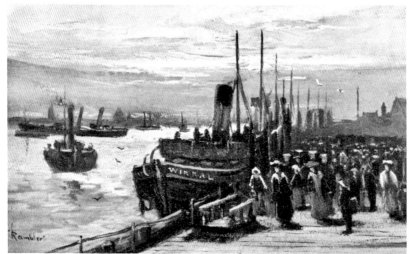

Passengers queue to board a Mersey ferry, on a dark and stormy day on the River Mersey. The Birkenhead ferry *Wirral* was built by J. Jones & Sons, in 1890, and was the second ferry to carry the name.

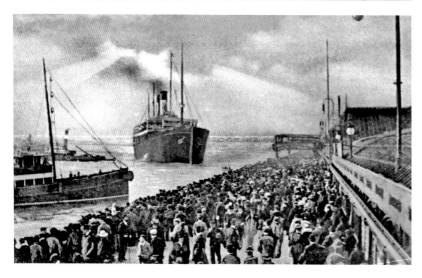

Large crowds of people watch Alexandra tugs assist a liner to berth at Princes Landing Stage.

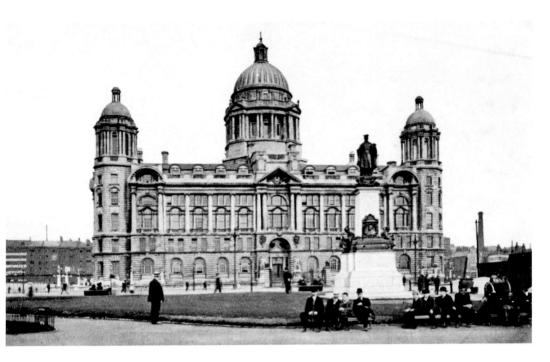

Office workers enjoy the lunchtime sunshine outside the Mersey Dock's offices at the Pier Head.

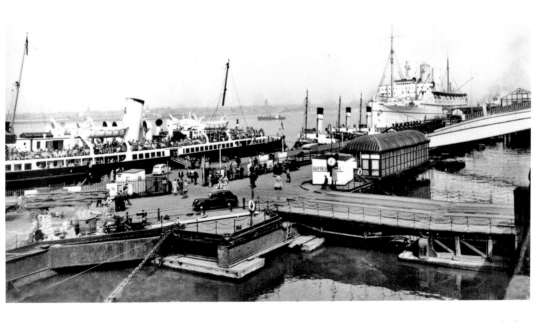

The Liverpool & North Wales Steamship Company vessel *St Seiriol* prepares to sail to Llandudno and Menai Bridge, North Wales. She was built by Fairfield's, in 1931, for summer services from Llandudno, round Anglesey, to Douglas, Isle of Man and some Liverpool to Llandudno and Menai Bridge sailings. She was a slightly smaller version of *St Tudno* and, apart from war service between 1939–45, she served the company until her withdrawal in 1961. Her last voyage was a return sailing between Llandudno and Douglas, on 6 September 1961, and she was sold to ship-breakers in Ghent the following year.

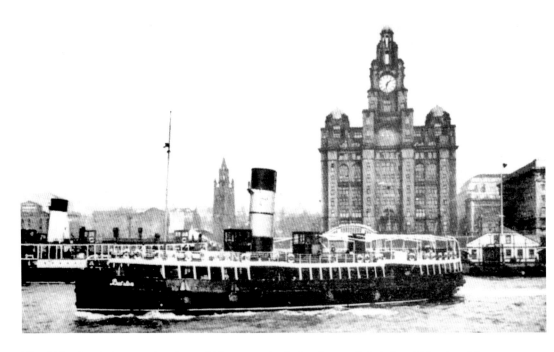

The Birkenhead Corporation ferry *Bidston* was built by Cammell Laird at Birkenhead in 1933, replacing the 1903 vessel of the same name. *Bidston* entered service on 27 February 1933, had a gross tonnage of 487 tons and was certified to carry 1,433 passengers.

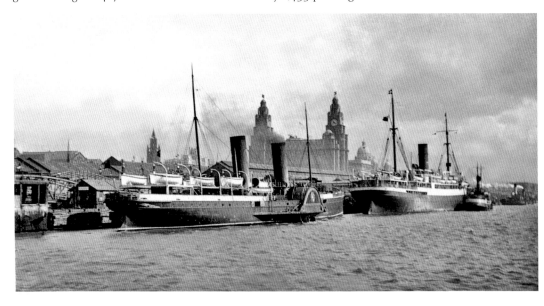

The Isle of Man Steam Packet paddle steamer *Mona's Queen*, at the north end of Princes Landing Stage. *Mona's Queen* entered service in 1885, and was built by the Barrow Shipbuilding Company Ltd. She actually started her career on the Fleetwood to Douglas service, but was soon transferred to the Liverpool route, returning to Fleetwood in 1890. She was requisitioned by the Admiralty in 1915, and served as a troop transport in the First World War, sinking a German submarine. She returned to service in 1919, after an overhaul by Cammell Laird, and was sold for breaking up at Port Glasgow in 1929.

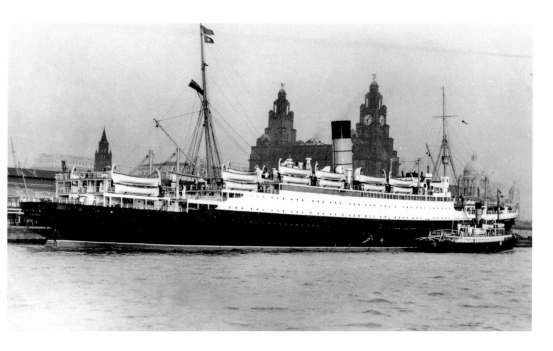

The Cunard liner *Aurania* at the landing stage. She was built in 1924, by Swan, Hunter & Wigham Richardson at Newcastle. In 1928, she was transferred to the London to New York service, and was requisitioned by the Admiralty in 1939, becoming an Armed Merchant Cruiser and used in convoy escort duties. In July 1941, she collided with an iceberg between Iceland and Halifax, but was able to continue on her voyage. Later that year, she was torpedoed but was able to reach the Clyde, where she was laid up. The following year she was converted into a Heavy Repair Ship and renamed *Artifex*. She was re-boilered in 1948, and sold to be broken up at La Spezia in 1961.

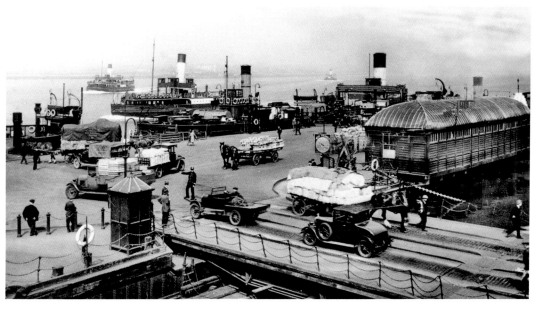

A vehicle queue at the bottom of the floating roadway to travel to Seacombe and Woodside on the luggage boats.

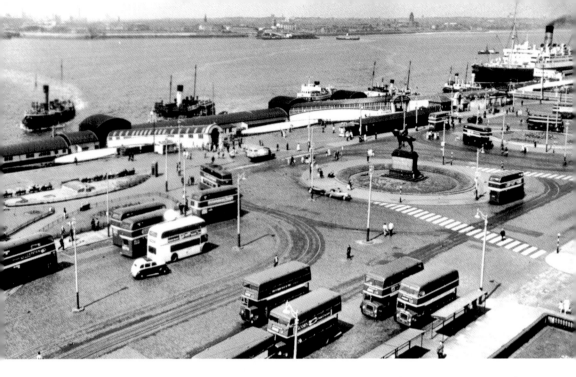

Commuters emerge from the tunnel leading down to the Birkenhead, Seacombe, New Brighton and Egremont ferries as a Cunarder prepares to take on tugs to move her into Huskisson Dock.

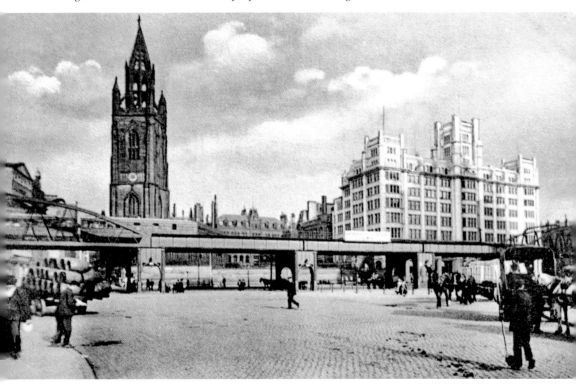

The Strand, showing Tower Building and St Nicholas Church.

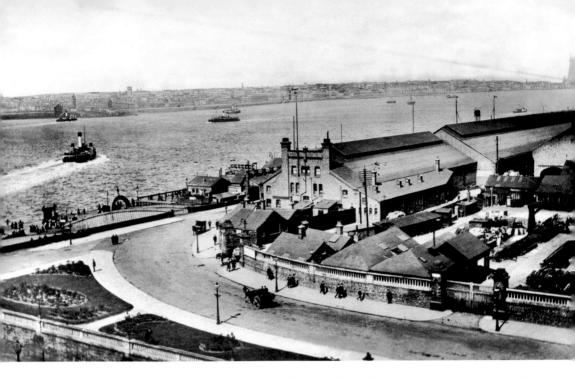

Two views of Princes Parade, looking northwards, show how the infrastructure has gradually changed over the years. The first photograph was taken in 1929 and the second in the late 1950s.

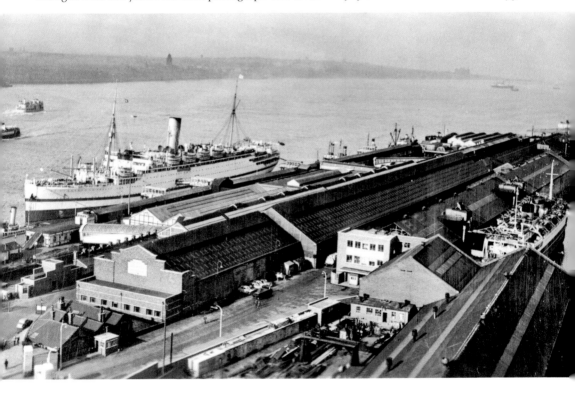

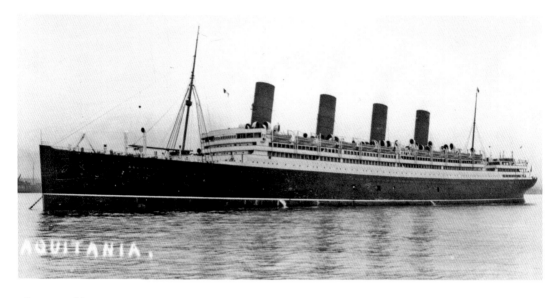

The Cunard liner *Aquitania* was built by John Brown & Company, on the Clyde, and sailed on her maiden voyage from Liverpool on 30 May 1914. However, after only completing three voyages, she was taken over by the Admiralty and converted into an Armed Merchant Cruiser under the White Ensign. It was soon discovered that she was unsuitable for this role, and she was laid up in Liverpool until the following year, when she emerged as a troop transport, and later, a hospital ship. In 1918, she carried over 60,000 troops from the United States, and took them home when the war ended. *Aquitania* returned to peacetime duties on 19 February 1919, sailing from Liverpool to New York, and she was converted to oil burning by Swan, Hunter & Wigham Richardson later that year. She sailed alongside *Mauretania* and *Berengaria*, which had replaced *Lusitania*, tragically lost in the First World War off Ireland. In 1936, she was operating from Southampton, opposite *Queen Mary*, and often achieved 24.87 knots on a transatlantic crossing. At the start of the Second World War, she was again requisitioned as a troopship, and sailed to Australia and the Middle East, and helped to repatriate American forces personnel at the end of hostilities. Following a charter to the Canadian Government, she was sold to the British Iron & Steel Corporation, and was broken up at Gareloch in 1950.

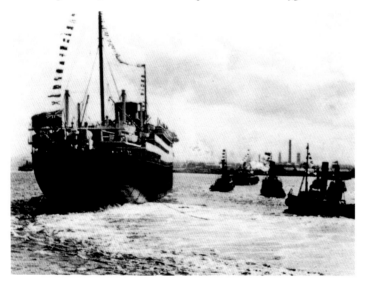

The White Star motorship *Britannic* sails on her maiden voyage from Liverpool on 28 June 1930. She was transferred to the London–New York service in 1935, becoming a troopship in August 1939. She sailed from Liverpool on 22 May 1948, on her first post-war voyage, to New York. *Britannic* was sold for breaking up at Inverkeithing in 1960.

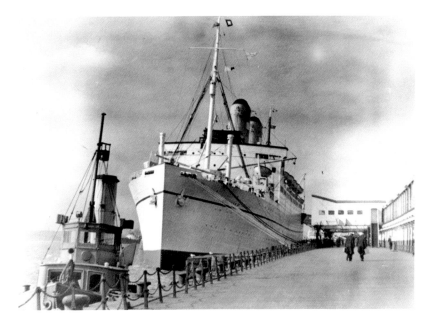

Empress of France was built as the *Duchess of Bedford* by John Brown & Co., on the Clyde. She was launched by Mrs Stanley Baldwin, wife of the British Prime Minister, and sailed on her maiden voyage from Liverpool to Quebec and Montreal on 1 June 1928. In 1933, she was chartered by Furness Withy to operate with *Monarch of Bermuda*, and in 1939 she became a troopship. While being refitted in 1947, her name was changed to Empress of France, and her first post-war sailing from Liverpool was on 1 September 1948, when she sailed to Quebec and Montreal. Her pepper-pot funnels were fitted in 1958, and on 19 December 1960 she left Liverpool to be broken up at Newport.

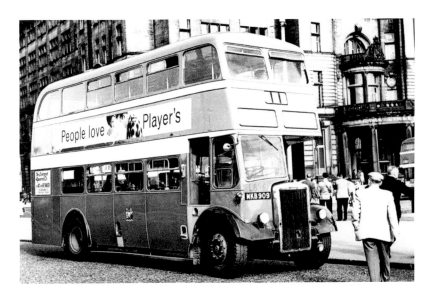

Liverpool Corporation bus, MKB 909, No. 17D, to Utting Avenue via Dale Street, waits outside the Royal Liver Building.

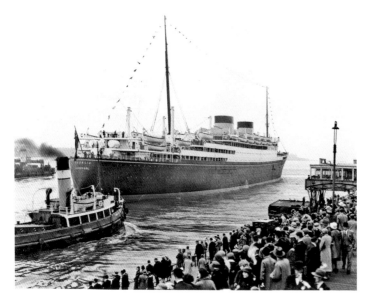

Georgic departs Princes Landing Stage on her maiden voyage to New York.

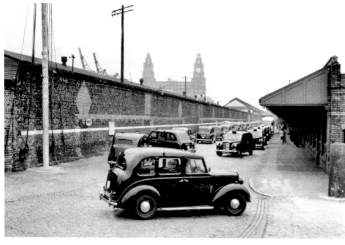

Taxis queue along Princes Parade as passengers arrive from a liner that has just arrived from Canada.

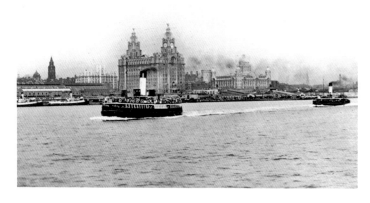

Wallasey Corporation ferries take passengers to Seacombe and New Brighton.

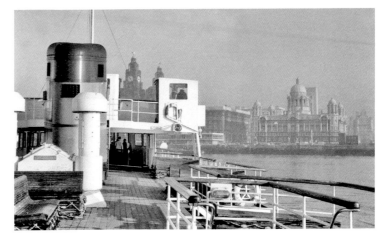

The Birkenhead
Corporation ferry
Woodchurch nears the
landing stage on a
trip from Woodside in
1965.

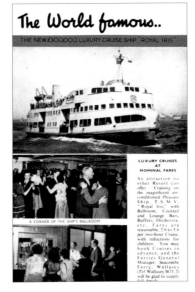

Wallasey Corporation
Ferries brochure of
1960.

The Birkenhead
Corporation
ferry *Thurstaston*
approaches Liverpool
landing stage in
the 1950s. She was
built by Cammell
Laird, at Birkenhead,
in 1930, and had
accommodation for
1,433 passengers.
Thurstaston was sold
to Dutch owners in
1961.

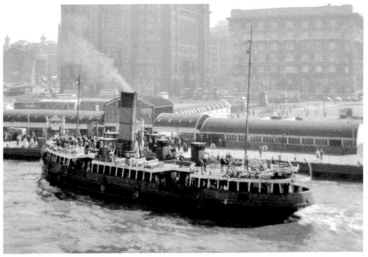

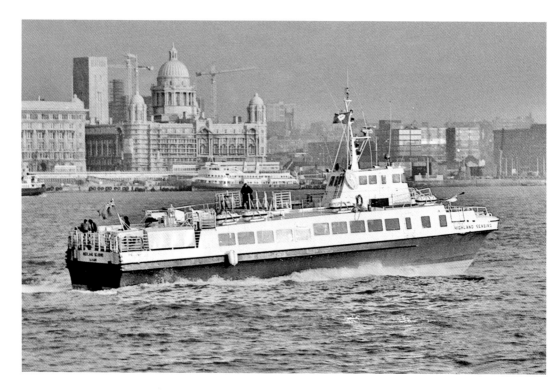

Highland Seabird passes *Royal Iris* in the river. She was chartered by Wallasey Corporation in 1982, to evaluate the use of this type of vessel on ferry services on the Mersey. On 20 December that year, heavy winds and a fast tide swept her behind the Landing Stage. She was there for forty-five minutes before being rescued by the *Royal Iris*, which pulled her clear. The trials proved unsuccessful and she was returned to her owners, Western Ferries Limited.

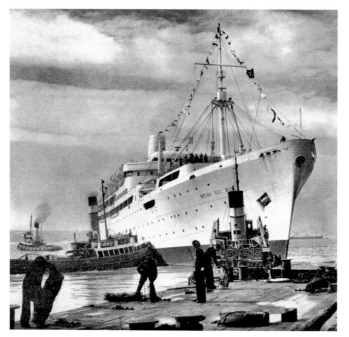

The Pacific Steam Navigation passenger vessel *Reina Del Mar* is helped to her berth at Princes Landing Stage by Alexandra tugs. *Reina Del Mar* was built by Harland & Wolff, at Belfast, in 1956, for the service from Liverpool to South America, via the Panama Canal. In 1963, she was chartered to the Travel Savings Association, and was converted to a cruise liner by Harland & Wolff the following year. In 1969, she was owned by the Royal Mail Line and sold to the Union Castle Line in 1973. She was broken up in Taiwan in 1975.

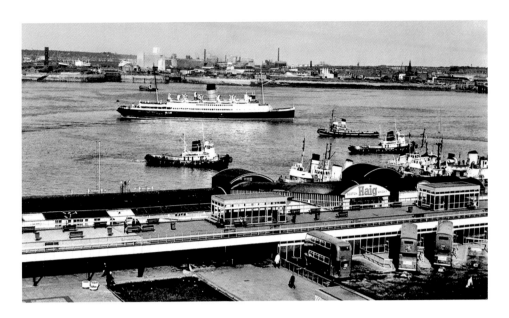

The Isle of Man Steam Packet Company vessel *Lady of Mann* moves astern from the stage on a sailing to Douglas, Isle of Man. She was built by Vickers Armstrong Ltd, at Barrow, in 1930, and operated as a troopship during the Second World War. She was broken up at Dalmuir in 1971.

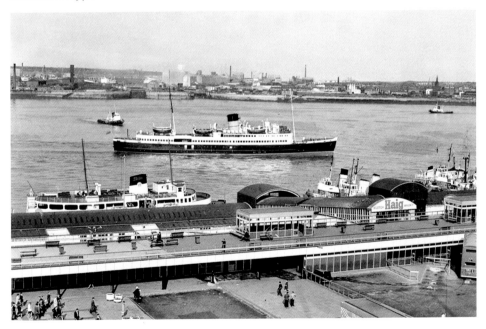

Manxman arrives 'light' from Douglas as Wallasey Corporation's *Royal Daffodil* operates the Seacombe ferry service. *Manxman* was built in 1955 by Cammell Laird, at Birkenhead, and operated on all of the Isle of Man Steam Packet services in the Irish Sea. She was withdrawn from service in 1982, and has spent time at Preston and Hull in various roles. However, she has spent some time laid up at Sunderland while several preservation societies have attempted to secure finance for her to return to the Mersey.

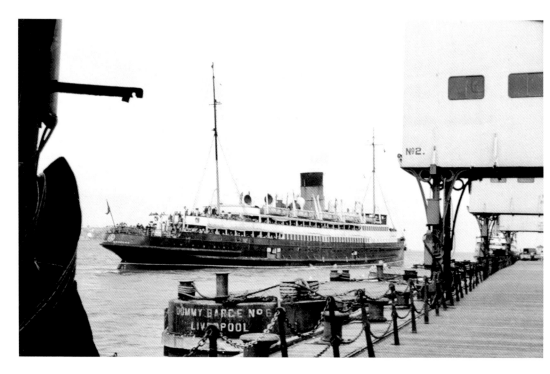

Ben My Chree arrives from the Isle of Man, on a Saturday morning, in the summer of 1966. She was also built by Cammell Laird, at Birkenhead, and sailed on her maiden voyage from Liverpool to Douglas on 29 June 1927. During the Second World War, she was fitted with six landing craft, and on 6 June 1944 she was at Omaha Beach as Headquarters ship for the 514th Assault Flotilla. At the end of the war, she was returned to the Isle of Man Steam Packet and arrived at Morpeth Dock, Birkenhead on 11 May 1946. Following an overhaul by Cammell Laird, she entered service on 6 July that year. She was taken out of service in 1965, and was sold and towed to ship-breakers at Ghent later that year.

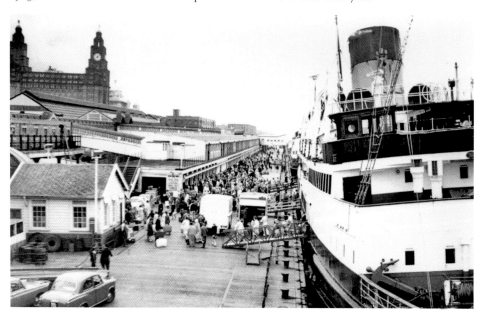

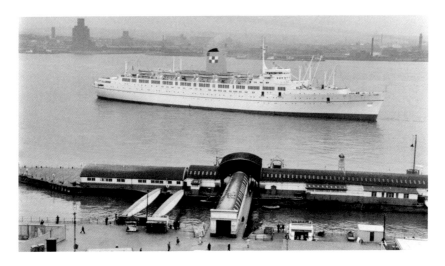

The Canadian Pacific liner *Empress of Britain* arriving at Princes Landing Stage. She was launched by Her Majesty Queen Elizabeth, on 22 June 1955, at the yard of Fairfield Ship Building & Engineering Company on the Clyde. *Empress of Britain* sailed from Liverpool to Quebec and Montreal on her maiden voyage on 20 April the following year. She was chartered to the Travel Savings Association in 1963, and sold to the Greek Line the following year, becoming *Queen Anna Maria*. She sailed on their transatlantic service until 1975 when she was laid up at Piraeus. In December that year, she was sold to the Carnival Cruise Line and renamed *Carnivale*. She was then renamed *Fiesta Marina* in 1994, and later *Olympic*. In 1997, she became *Topaz*, operating as a cruise ship for Thomson Cruise Line, and then chartered as the peace boat until 2008, when she was laid up at Singapore. She was sold to ship-breakers at Alang later that year.

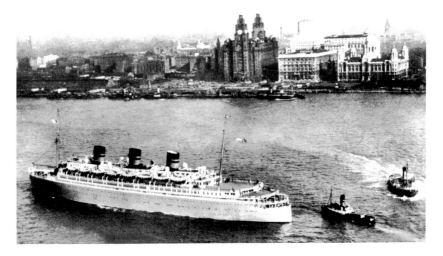

Furness Withy's *Queen of Bermuda* passes the Pier Head following an overhaul at Cammell Laird's shipyard, at Birkenhead. With her sister ship, *Monarch of Bermuda*, she operated on the New York to Bermuda service. *Queen of Bermuda* was built in 1933, and converted to an Armed Merchant Cruiser in 1939, seeing service in the South Atlantic, and later as a troopship. She returned to service on 12 February 1949 and continued until 1966, when she was sold and broken up at Faslane.

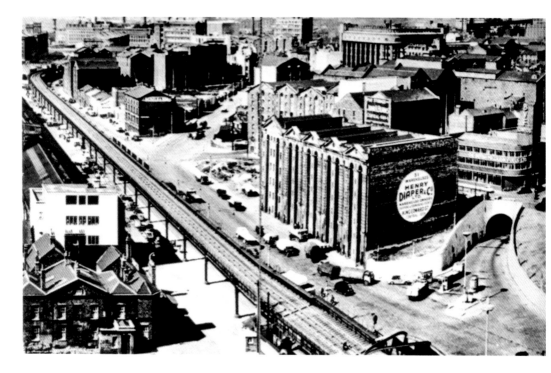

Henry Diaper & Company Ltd warehouses and the Dock Road exit from the Queensway Mersey Tunnel at the rear of the Pier Head. The Overhead Railway Line leads north to Seaforth.

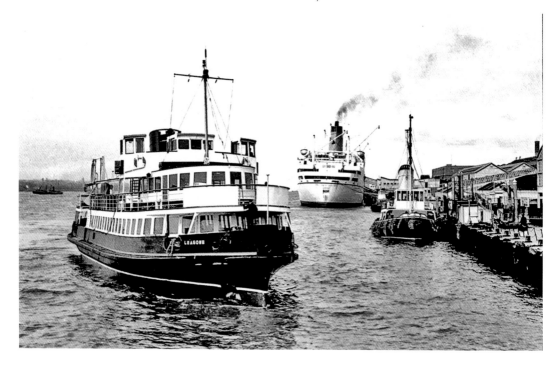

The Wallasey Corporation ferry *Leasowe* berths at the landing stage, with the Canadian Pacific liner *Empress of England* at Princes Landing Stage.

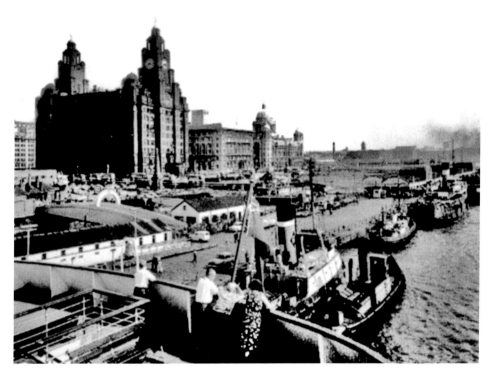

A view of the Pier Head from a passenger liner berthed at Princes Landing Stage in the 1960s.

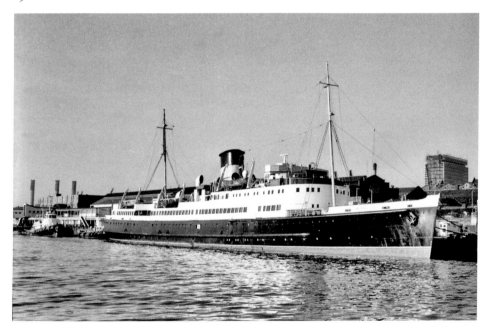

Mona's Isle at the south end of Princes Landing Stage. She entered service in 1951, and was sold by the Isle of Man Steam Packet Company in 1980, for breaking up in Holland.

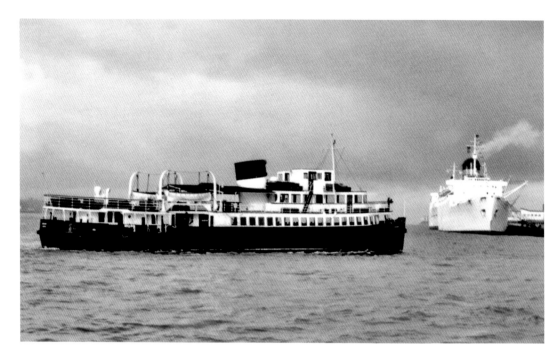

The Wallasey ferry *Leasowe* arrives at the landing stage, as the Cunard liner *Franconia* prepares to sail from Princes Landing Stage.

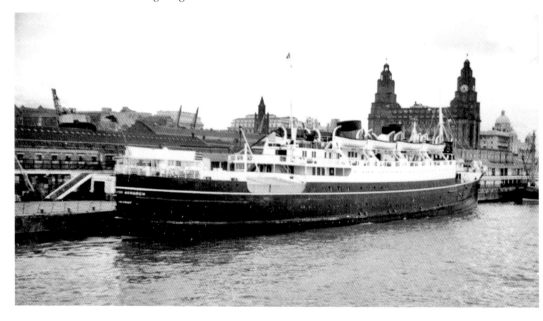

The Belfast Steamship Company's *Ulster Monarch*, at the north of Princes Landing Stage. She was built in 1929 for the Liverpool to Belfast passenger service, and was engaged in trooping duties during the Second World War. She was involved in Operation Torch, during the invasion of North Africa and the invasion of Italy, was damaged when she was bombed off Cape Bon on 19 August 1943, and managed to sail to Tripoli. She returned to peacetime service at the end of the war, was sold in 1966, and broken up at Ghent.

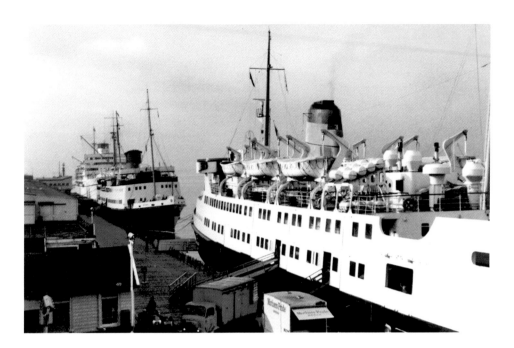

Bread is delivered to the Isle of Man steamers *Manx Maid* and *Manxman*, as the educational cruise ship *Dunera* berths at the south of Princes Landing Stage. *Dunera* was built in 1937 for the British India Steam Navigation Company. On 10 July 1940, Italian and German 'enemy aliens' were embarked on *Dunera* at Liverpool, to be deported to Australia. The ship arrived at Sydney, and the appalling conditions experienced by the passengers became known. On arrival, they set up their own community, and when the Japanese attacked Pearl Harbour later in the war, the prisoners were declassified as 'friendly aliens'. The community set up at Hay in New South Wales is marked by a plaque stating:

This plaque marks the 50th anniversary of the arrival from England of 1,984 refugees from Nazi oppression, mistakenly shipped out on HMT "Dunera" and interned in Camps 7 & 8 on this site from 7. 9. 1940 to 20. 5. 1941. Many joined the AMF on their release from internment and made Australia their homeland and greatly contributed to its development. Donated by the Shire of Hay – September 1990.

Dunera was later involved in operations in Madagascar, Scilly, and Southern France, and in 1945, she transported occupation personnel to Japan after the Japanese surrender. She became a troopship in 1951, and in 1960 she was converted to an educational cruise ship. She operated in this role for the next seven years, before being sold and broken up in Bilbao.

Birkenhead, Seacombe and New Brighton ferries cope with heavy crowds of passengers on a summer Sunday, while two Alexandra tugs prepare to sail to allow an Isle of Man steamer to berth at the stage.

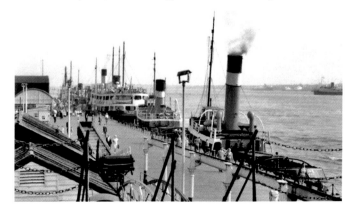

ON MERSEYSIDE
WE HAVE A LEFT BANK
AND A RIGHT BANK

Whether your stay on Merseyside is inspired by business
or pleasure you'll find a wealth of things to see and do.

With so many sights to take in you can't afford to waste
time searching for a bank. With Barclays there's no need to.
Our 68 branches throughout Merseyside ensures that we're
always on your doorstep, providing the benefits of a
comprehensive service, from personal and business loans to
insurance and mortgages.

The professional expertise of Barclays' staff is matched
by a warm and courteous regard for each customer's
individual needs, in the best tradition of Merseyside
hospitality.

Even outside banking hours, obtaining cash needn't
be a problem: 43 Barclays cash dispensers provide an
instant cash service, 24 hours per day, 7 days a week.

Whichever side of the Mersey you
visit, there's only one bank on
Merseyside, Barclays – the Right Bank.

+++ YOU'RE
BETTER OFF
TALKING TO
BARCLAYS

Above: The bridge of the Isle of Man steamer *Manxman*.

Left: Advert for Barclays Bank.

Opposite below: Carinthia anchors in the Mersey, waiting for a berth at Princes Landing Stage, to load passengers for a voyage to Canada. She was built by John Brown & Company, on the Clyde in 1956, for the Cunard Line Canadian service, from Liverpool to Quebec and Montreal. In 1968, she was sold to Sitmar Line, becoming *Fairland and Fairsea* in 1971. She was acquired by the P&O Line in 1988 and was renamed *Fair Princess*, becoming *China Seas Discovery* in 2000. In 2005, after being laid up for several years, she was broken up at Alang.

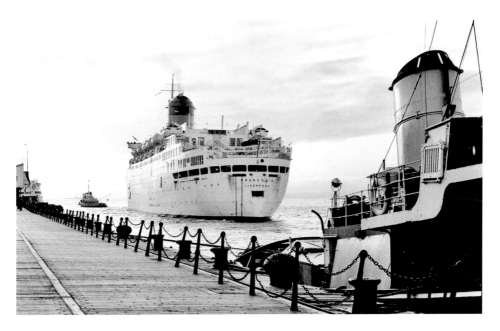

The Cunard liner *Franconia* arriving at Princes Landing Stage. She was built in 1955, as *Ivernia,* and sailed on her maiden voyage on 1 July that year, from Greenock to Quebec and Montreal because of a catering strike. She resumed her service from Liverpool on her second voyage. In 1963, she was rebuilt as a cruise ship and renamed *Franconia*. In November 1967, she became the last Cunard liner to terminate a scheduled sailing at Liverpool, and was put up for sale in 1971 and laid up at Southampton. *Franconia* was bought by Russian interests two years later and renamed *Fedor Shalyapin* for a service from Southampton to Australia. She was renamed *Salona* for the delivery voyage to the ship-breakers at Alang, where she arrived on 6 February 2004.

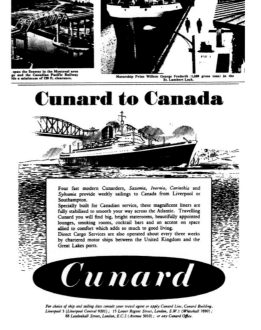

The Birkenhead ferry *Overchurch* and the Wallasey ferry *Leasowe* at Liverpool landing stage.

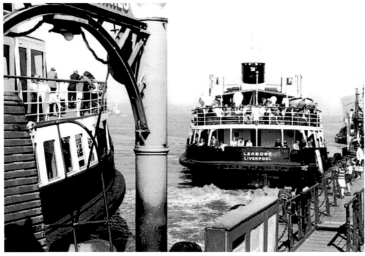

Wallasey ferries *Egremont* and *Leasowe* on the Seacombe and New Brighton services.

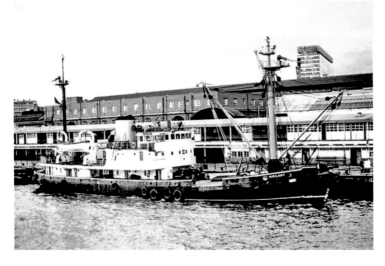

The Mersey Docks & Harbour Board salvage vessel *Vigilant* at Princes Landing Stage. She was built by J. Thornycroft in 1953, renamed *Staunch* in 1978, and broken up at Garston that year.

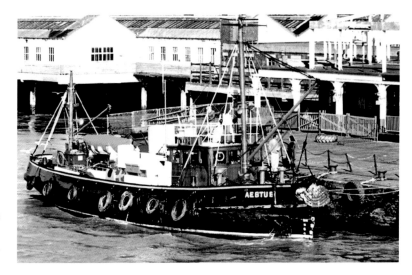

The Mersey Docks & Harbour Board survey vessel *Aestus* at the north end of the stage. She was built in 1950 and employed on buoy maintenance and survey work. *Aestus* was broken up in 1986.

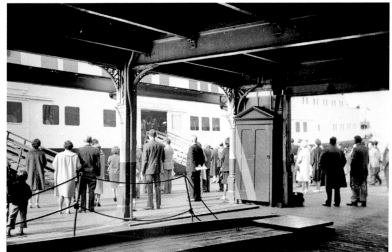

Family and friends greet passengers arriving from Douglas, Isle of Man, on the car ferry *Manx Maid* in 1969.

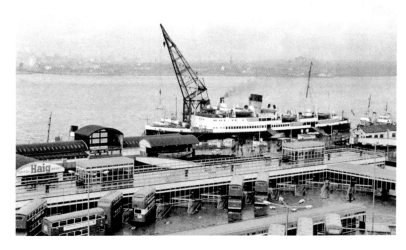

A bus is loaded, by the Mersey Docks floating crane, onto the Isle of Man steamer *King Orry*, to be shipped to the Isle of Man in 1968.

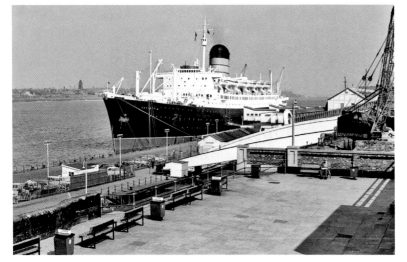

Carinthia at Princes Landing Stage after a voyage from Canada. She was later towed to Huskisson Dock to unload her cargo at the Cunard berth in the dock system.

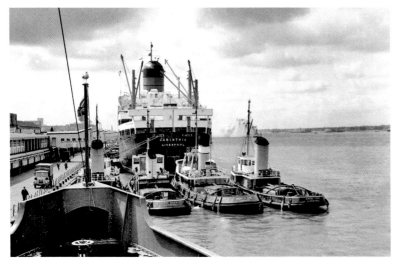

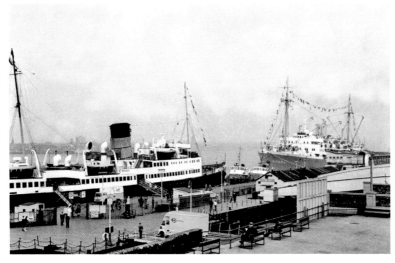

The Isle of Man Steamer *Mona's Isle* and Elder Dempster's *Apapa*.

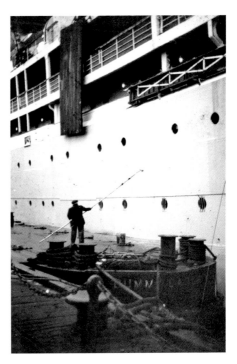

Right: The Elder Dempster Line's *Apapa* is given a painting prior to her sailing to West Africa in 1966. She was built in 1948 and was the sister ship of *Accra*. *Apapa* took her final sailing on 20 September 1968, before being sold to Hong King interests and renamed *Taipooshan* for the Hong Kong to Singapore and Penang service. She was sold to ship-breakers in 1975.

Middle: Left to right: *Lady of Mann, Caledonia, Apapa* and *Snaefell* at Princes Landing Stage.

Bottom: The Canadian Pacific Steamships' passenger liner *Empress of Britain* arrives at Liverpool.

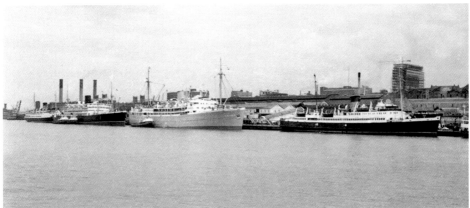

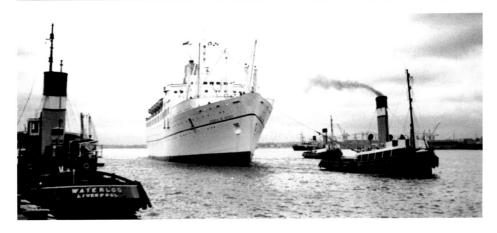

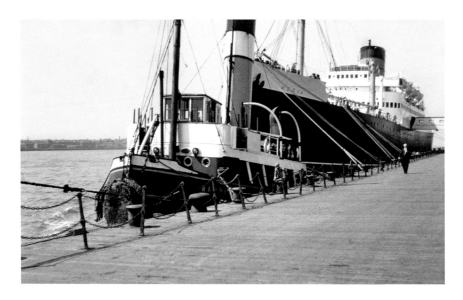

Cunard liner *Media* loads passengers and luggage at Princes Landing Stage. *Media* was another product of John Brown & Co., and was built on the Clyde, in 1947, and operated with her sister *Parthia* on the Liverpool to New York service. Both vessels were passenger and cargo ships, and loaded cargo at Huskisson Dock prior to sailing from the landing stage, where they embarked their passengers. However, by 1961 they became uneconomic to operate and were sold. *Media* became *Flavia* and was completely rebuilt for a service from Genoa to Australia via the Suez Canal. She was later employed cruising in the Mediterranean, and was sold to the Costa Line for cruising out of Miami in 1969. She was renamed *Flavian* in 1982 and was laid up at Hong Kong. In 1986, she was sold to Lavia Shipping of Panama and renamed *Lavia*. However, on 7 January 1989, she was damaged by a serious fire and declared a total loss.

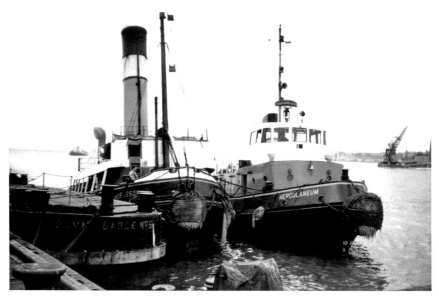

The Alexandra tugs *Herculaneum* and *Huskisson* at the landing stage.

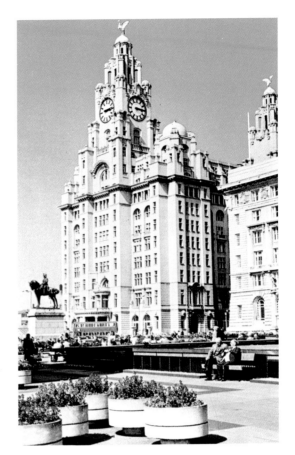

Right: The Royal Liver Building was built in 1911; one of the first buildings in the world to be built using reinforced concrete. It was designed by W. Aubrey Thomas, and the foundation stone was laid on 11 May 1908. It was opened by Lord Sheffield on 19 July 1911, and stands 295 feet high with thirteen floors.

Below: Left to right: *Lady of Mann, Ben My Chree,* Royal Yacht *Britannia* and her Royal Navy escort.

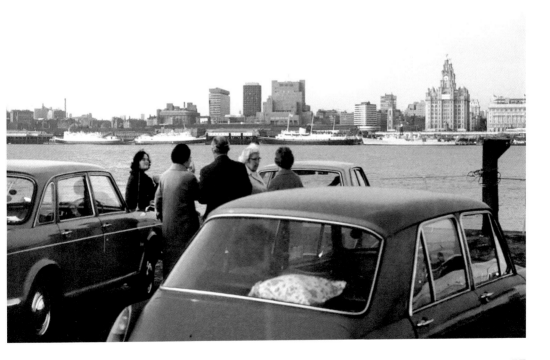

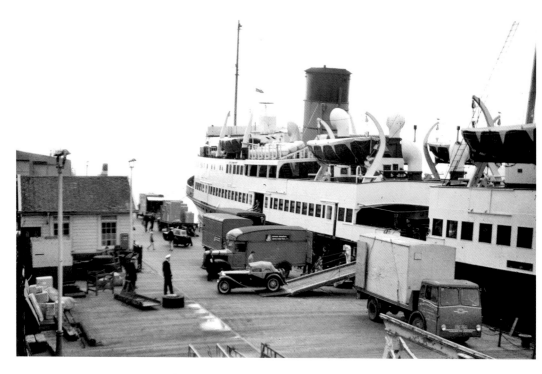

The first officer of *Manxman* supervises the loading of a sports car onto the vessel at the landing stage.

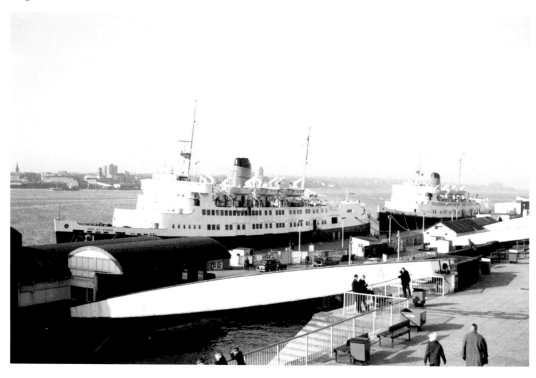

The Isle of Man car ferries *Ben My Chree* and *Manx Maid* at their berth on the landing stage.

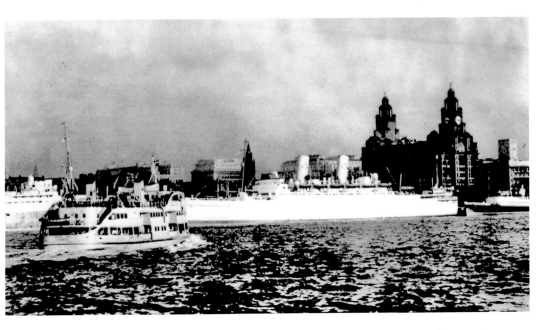

The Wallasey ferry *Royal Iris*, on the Seacombe to Liverpool service, passes the Canadian Pacific liner *Empress of France*, berthed at Princes Landing Stage.

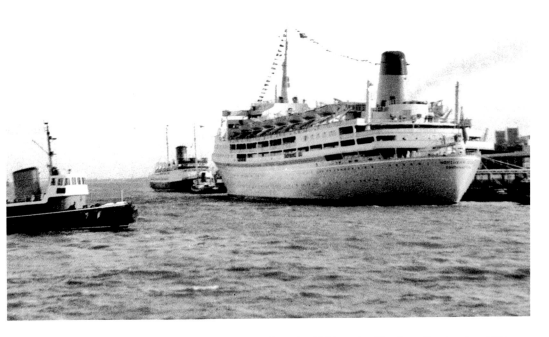

Following trials and delivery to her owners, Shaw Savill Line, the *Northern Star* berths at Princes Landing Stage. She then proceeded to Southampton, where she sailed on her maiden voyage on 10 July 1962 with over 1,400 passengers and 480 crew onboard. She was employed with her sister, *Southern Cross*, on round-the-world voyages, until she was withdrawn from service in 1975. Sold to the ship-breakers, she arrived at Taiwan on 11 December that year to be broken up.

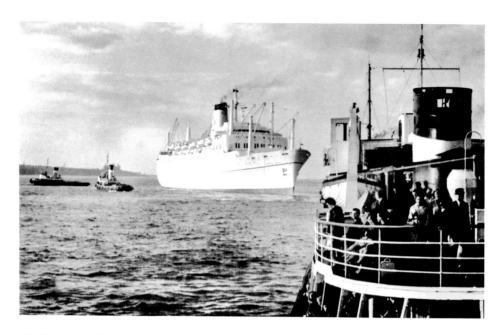

The *Empress of Canada* is towed astern after disembarking passengers at the landing stage. She was built by Vickers Armstrong Ltd, on the Tyne, and sailed from Liverpool to Quebec and Montreal via Greenock, on 24 April 1961. She was sold to the Carnival Cruise Line in 1972 and was renamed *Mardi Gras, Olympic* in 1993, *Star of Texas* in 1994 and *Apollon* in 1996, when she returned to the Mersey for a series of cruises by Direct Cruises. She was sold to ship-breakers in 2003.

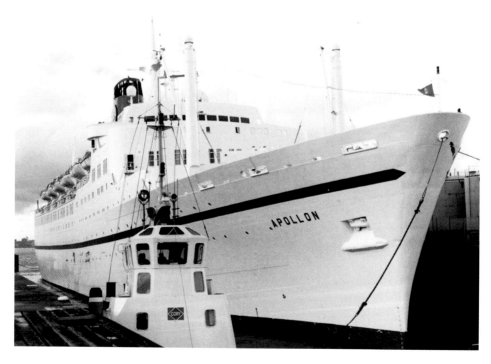

Apollon entering Langton lock, Liverpool in 1999.

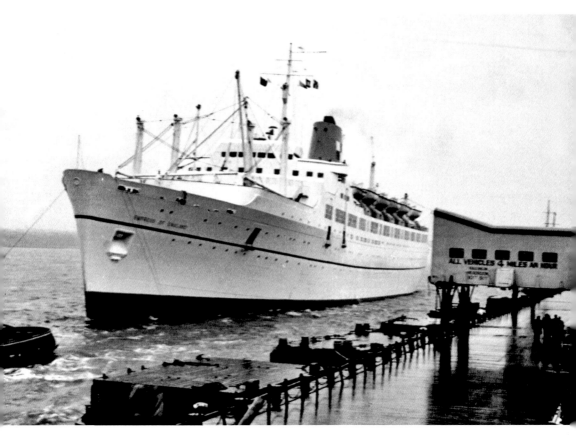

Empress of England operated for Canadian Pacific Steamships from 1957 to 1970, when she was sold to the Shaw Savill Line and renamed *Ocean Monarch*. She operated on their services to Australia until 1975, when she was sold to ship-breakers at Taiwan.

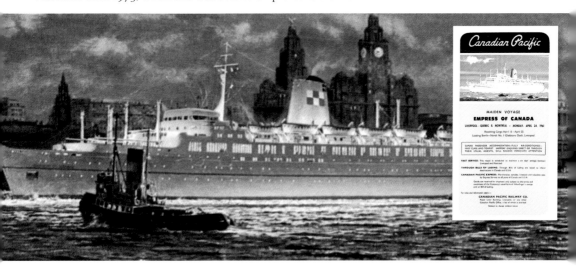

Canadian Pacific Steamship brochures featuring *Empress of England* at Princes Landing Stage and the maiden voyage of *Empress of Canada* on 24 April 1961.

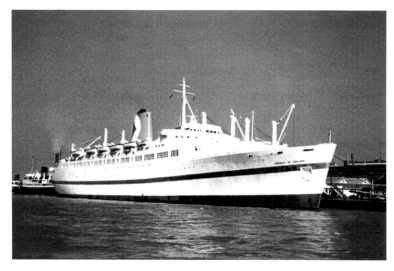

Empress of England in her final Canadian Pacific livery at Princes Landing Stage.

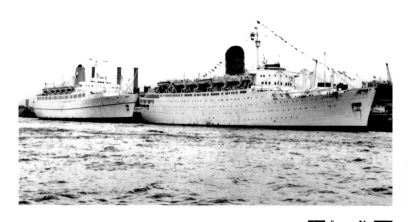

Empress of Britain and *Franconia* at Princes Landing Stage.

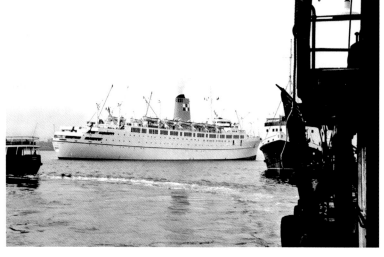

Empress of Britain berths at the landing stage, as the Isle of Man steamer *Snaefell* loads passengers for a voyage to Douglas, Isle of Man.

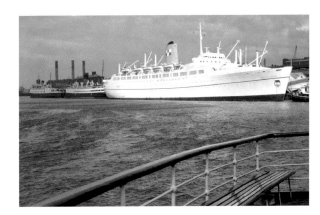

Left to right: *Manx Maid, Lady of Mann* and *Empress of England.*

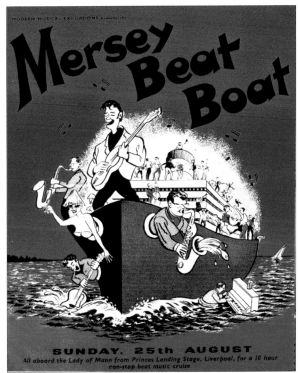

Advertisement for a 'Mersey Beat Boat' cruise from Princes Landing Stage on the Isle of Man steamer *Lady of Mann* in the 1960s.

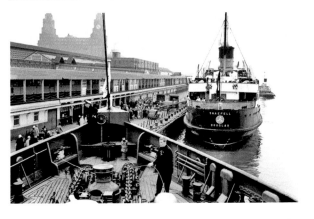

The Isle of Man steamer *Snaefell* loads passengers as the *Lady of Mann* moves astern in the river.

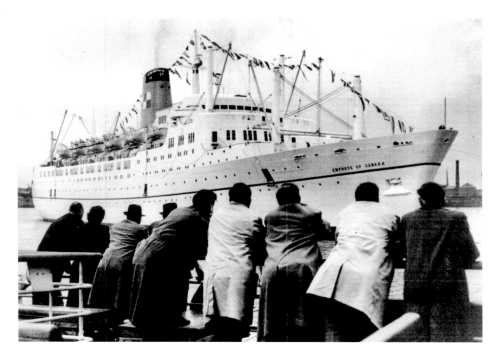

The *Empress of Canada* sails on her maiden voyage from Liverpool on 24 April 1961.

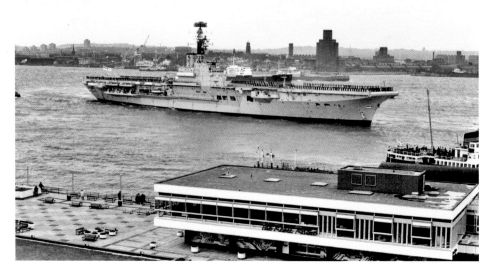

The Royal Navy aircraft carrier HMS *Albion* arrives at Princes Landing Stage in the 1960s, on a courtesy visit to Liverpool. *Albion* was built by Swan, Hunter & Wigham Richardson, and was launched on 16 May 1947. She was commissioned in 1954 and involved in the Suez crisis when operating in the Mediterranean in 1956. In the following years, she visited the Far East, Australia, New Zealand, the South Atlantic and the Indian Ocean, returning to Portsmouth to pay off. In 1961, she was converted to a commando carrier and joined the Far East fleet. In 1967, she was part of the force involved in the withdrawal from Aden and also the withdrawal of British forces from Singapore in 1971.She was sold in 1973 and broken up at Faslane Naval Base.

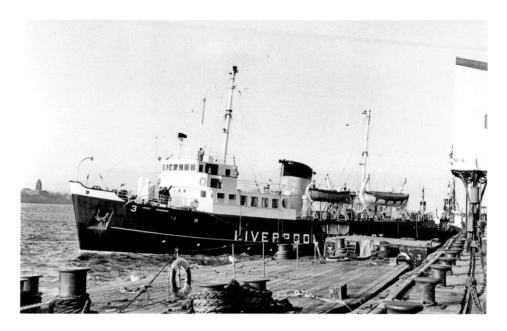

The pilot boat *Arnet Robinson* was owned by the Mersey Docks & Harbour Board, and was used to transport Mersey pilots to vessels entering and leaving the Mersey. She was built in 1958 and converted to a hydrographic and seismographic research ship in 1982, renamed *Pensurveyor*. In 1988, she was bought by Turkish interests, converted to a ferry and renamed *Faith*.

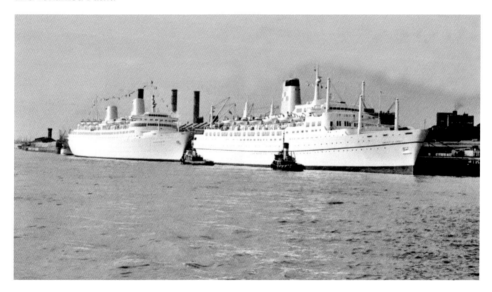

Kungsholm and *Empress of Canada*, berthed at Princes Landing Stage. *Kungsholm* was owned by Swedish America Line and was operating a cruise around Britain. Strong winds had caused her to cancel her call at Llandudno and she was diverted to Liverpool, where she spent the day. As well as cruising duties, *Kungsholm* operated on the Gothenburg and Copenhagen to New York service. She was sold in 1979 to P&O and renamed *Sea Princess*, operated by the Princess Cruise Division. She became *Victoria* in 1995, *Mona Lisa* in 2002, *Oceanic II* in 2006 and *Mona Lisa* again in 2008.

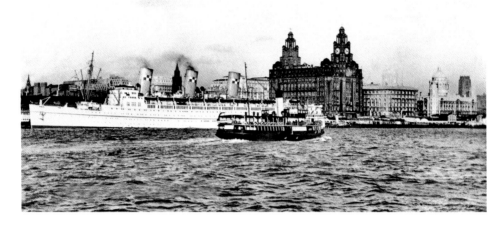

Wallasey Corporation ferry *Wallasey* passes the Canadian Pacific liner *Empress of Scotland*. *Empress of Scotland* was launched as *Empress of Japan* for service between Vancouver to Yokohama. She sailed on her maiden voyage from Liverpool to Quebec on 14 June 1930, returning to Southampton, and then sailing to Japan via Suez and Hong Kong. In 1939, she became a troopship, and was renamed *Empress of Scotland* in 1942. Following an overhaul at Glasgow, she returned to the Liverpool to Canada service in 1950. She was sold to the Hamburg–Atlantic Line in 1958, renamed *Hanseatic* and sailed from Hamburg, Le Havre, and Southampton to New York, operating cruises during the winter months. On 7 September 1966, she suffered a serious fire at New York and was towed to Hamburg, where she was sold for scrap.

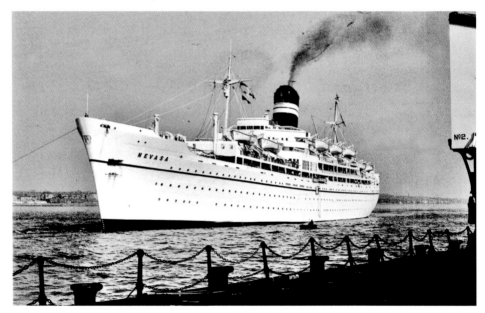

Nevasa was built in 1956 for the British India Steam Navigation Company, and operated as a troop transport until the service was ended in 1962, when she was laid up in the River Fal. During 1964/65, she was converted to an educational cruise ship, with accommodation for 307 passengers in cabins and 783 children in dormitories. *Nevasa* was broken up in 1975.

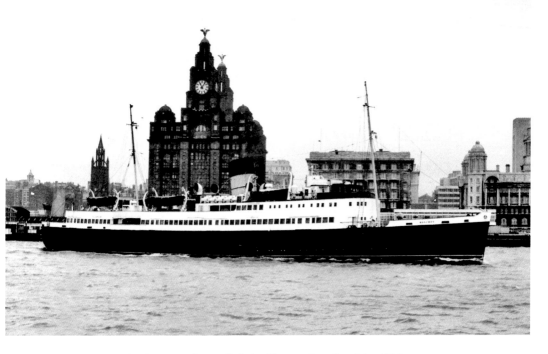

Manxman passes the Pier Head on a 'light' sailing to Douglas, Isle of Man.

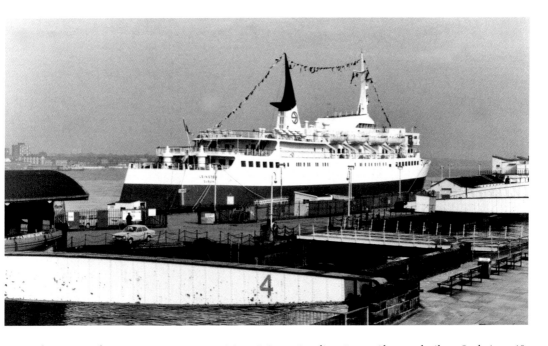

The B&I car ferry *Leinster* on a rare visit to Princes Landing Stage. She was built at Cork, in 1968, for the Dublin to Liverpool route and was renamed *Innisfallen* in 1980, becoming *Ionian Sun* in 1986. She operated on the Swansea to Cork route in 1990, and became *Chams* in 1993, *Ionian Sun* again in 1993 and *Merdif* in 2001. She was broken up in 2004.

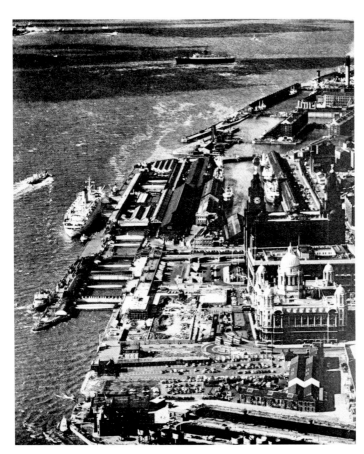

Left: An aerial view of the Pier Head and Landing stage.

Below: Empress of Canada and *Sylvania* at Princes Landing Stage.

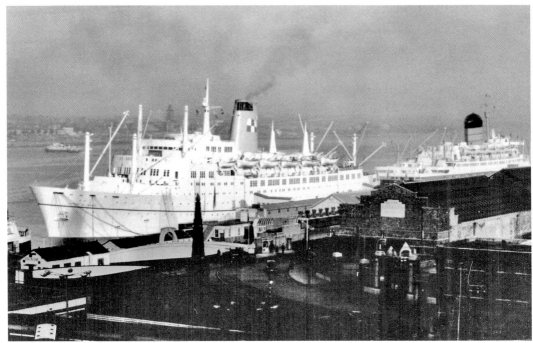

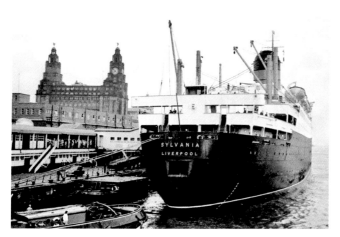

Sylvania was built for the Cunard Line by John Brown & Co., on the Clyde, in 1957. She replaced *Britannic* on the Liverpool to New York rout, and in 1965 she made the first Cunard cruise out of Liverpool since 1939. During her overhaul, in 1967, she had her hull painted white and was sold to the Sitmar Line in 1968, becoming *Fairwind*. In 1988, she was sold and renamed *Dawn Princess* for Princess Cruises, becoming *Albatros* in 1994. She returned to the Mersey on one occasion while named *Albatros* and is shown anchored off the Pier Head. She was broken up at Alang in 2004.

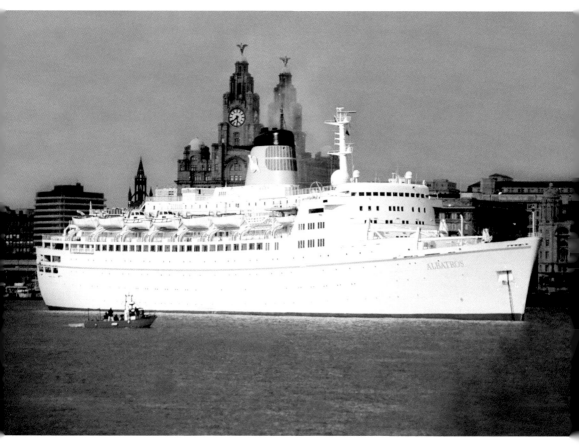

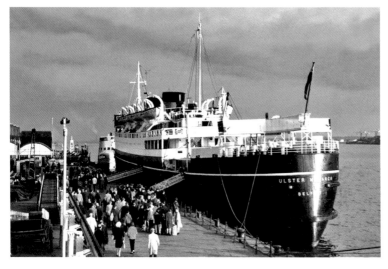

The Belfast Steamship Company's *Ulster Monarch* on a rare sailing to Belfast from Princes Landing Stage.

Cars and vans are loaded onto the Belfast Steamship vessel *Ulster Prince* at Princes Landing Stage.

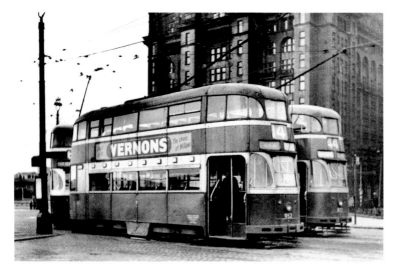

Liverpool Corporation trams, Nos 872 and 952, wait at the terminus at the Pier Head.

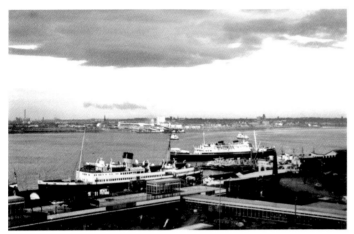

Ulster Monarch passes *Manxman* near Princes Landing Stage. The Wallasey ferries *Leasowe* and *Egremont* are shown in service on the Seacombe route.

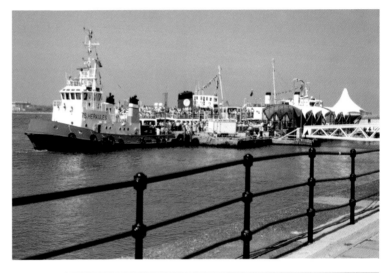

Crowds flock onto the Mersey Ferries *Woodchurch* and *Royal Iris,* on the occasion of the first visit of the Cunard liner *Queen Elizabeth 2* to the Mersey on 24 July 1990.

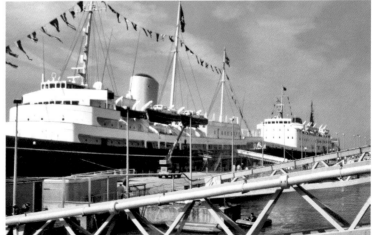

The Royal Yacht *Britannia* and *Lady of Mann* at the landing stage.

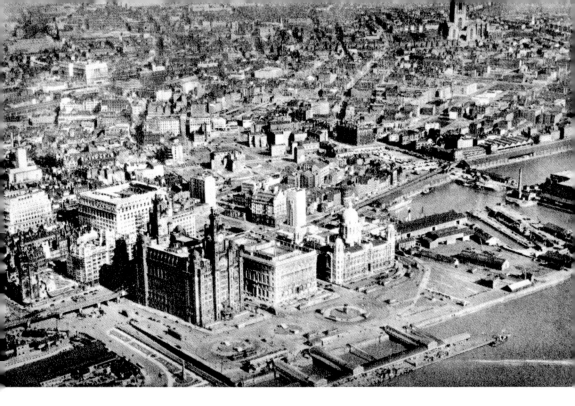

The Pier Head, showing the 'Three Graces': the Royal Liver Building, Cunard Building and the Mersey Docks & Harbour Board Building.

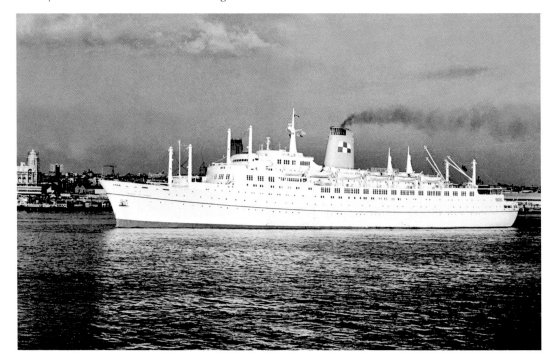

Empress of Canada sails past the Pier Head at the start of a voyage to Canada in 1964.

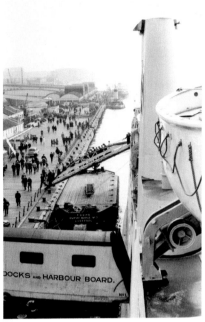

Otto Thoresen's *Viking II* at Princes Landing Stage, on 27 October 1964, when she also visited Avonmouth, Southampton, Hull, Newcastle and Leith. She was built to operate from Southampton to Cherbourg and Le Havre. She was named *Carferry Viking II* in 1964, became *Earl William* in 1977, *Pearl William* in 1992, *Mar Julia* in 1996, *Cesme Stern* in 1997 and *Windward II* in 2000. She became a Hotel in Chaguaramas, Trinidad & Tobago in 2008.

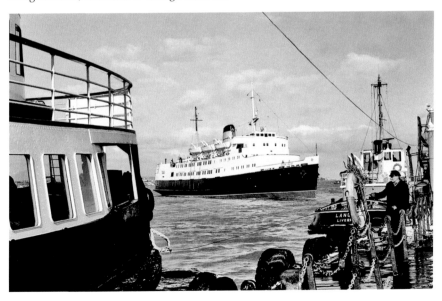

The Isle of Man car ferry *Manx Maid* moves astern in the river, on a voyage to the Isle of Man, as Wallasey Ferries' *Egremont* arrives from Seacombe.

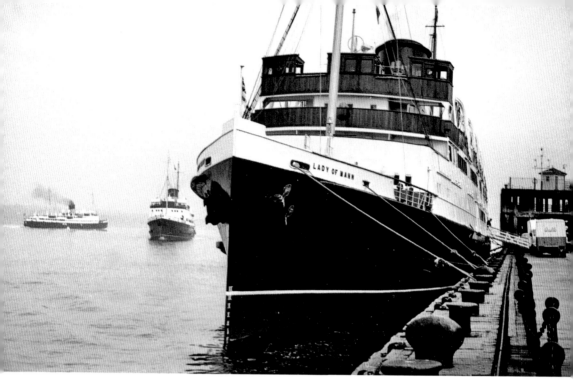

Left to right: The Isle of Man steamers *Mona's Isle, Snaefell* and *Lady of Mann*.

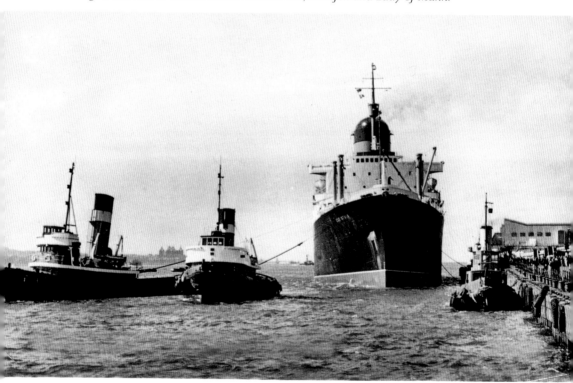

The Cunard liner *Carinthia* is assisted to the stage by Alexandra tugs.

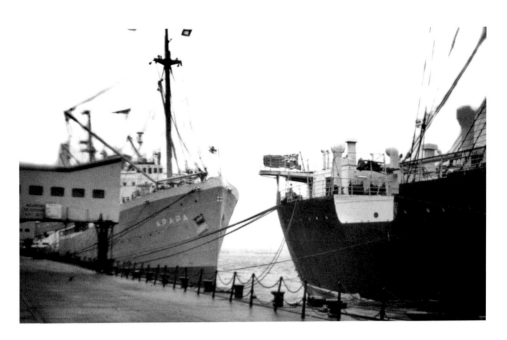

Elder Dempster Line's *Apapa* and Anchor Line's *Cilicia* on a wet summer's day in 1964.

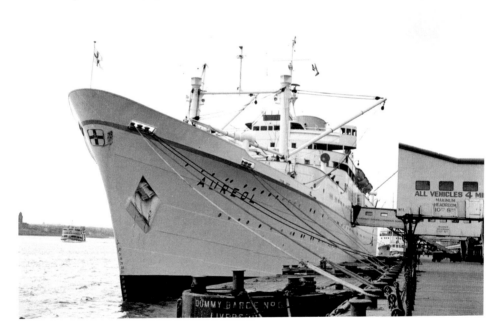

Aureol at Princes Landing Stage. She was built for Elder Dempster Line, in 1951, for their service from Liverpool to West Africa. Her sister ships on the service were sold by 1968, and *Aureol* made the last West African passenger sailing from Liverpool on 16 March 1972, before being transferred to Southampton. However, she was laid up in 1974 and sold the following year, becoming *Marianna VI* for use as an accommodation ship at Jeddah. She was overhauled at Piraeus in 1979, and berthed at Rabegh in 1980 to operate as an accommodation ship. In 1991, she was laid up off Piraeus and was broken up at Alang ten years later.

Above: *Carinthia Empress of Canada* and *Manx Maid* berthed at Princes Landing Stage.

Left: A list of vessels that took part in the Royal Review, off the Pier Head, on 21 June 1977.

COMPANIES TAKING PART IN THE ROYAL REVIEW
21st JUNE, 1977

1 Isle of Man Steam Packet Co. 'LADY OF MANN'
Funnel Red and Black.
Trade Liverpool to Isle of Man, Passengers and Cargo.

2 Lamport & Holt Line 'ROMNEY'
Funnel Black, White and Blue.
House Flag Red with Broad White horizontal stripe supporting L + H in Black.
Trading Brazil and River Plate. General Cargo.
Regular sailings from Liverpool commenced in 1863 pioneering all aspects of the South American Trade. In 1932 granted the privilege of flying the Liverpool Civic Flag from the Stem.
The Company is an associate of Blue Star Ship Management.

3 Elder Dempster Lines Ltd. 'EBOE'
Funnel Buff.
House Flag White Burgee bearing St. George's Cross with Crown at centre.
Trading World Wide - especially Far East, West Africa - general and bulk cargoes.
Originated in the African Steamship Company founded by MacGregor Laird in 1852 and in the British and African Steam Navigation Company founded by Alexander Elder and John Dempster in 1868.
Now a member of the Ocean Group.

4 Booker Line Ltd. 'BOOKER VANGUARD'
Funnel Broad White Band between Dark Blue Bands. Red Letter 'B' on White Band.
House Flag As for funnel.
Trading West Indies and North Coast of South America. Inward - Greenheart Timber, Rum, Raw Sugar in Bulk, Bagged Sugar. General Cargo outwards.
Founded by Josias Booker, a planter who shipped his produce to his brothers in Liverpool from whom he received supplies. A regular service commenced in 1835 that has continued to this day. In 1867 the service was known as the Liverpool Line but in 1911 the name was changed to Booker Line.

5 North West Water Authority 'GILBERT J. FOWLER'
Funnel Buff with Blue symbol on White ground.
House Flag Pale Blue background with Dark Blue symbol.
Trading Manchester to Liverpool.
Treated Sewage Sludge has been disposed of at sea by Manchester Corporation since 1897. The responsibility for this work was taken over by the Water Authority in 1974. There 4 vessels in the fleet.

6 John Kelly Ltd. 'BALLYRORY'
Funnel Black with Red, White and Blue Bands and Black 'K'.
House Flag Red Burgee with White 'K' and Blue Border top and bottom.
Trading Home and Near Sea Trade. Dry Bulk Cargoes.
Founded in 1840 by Samuel Kelly and remained in the family until 1948 when the Company was acquired by Wm. Cory & Sons Ltd. and Powell Duffryn Ltd. There are now 6 vessels in the fleet.

7 North West Water Authority 'CONSORTIUM'
Funnel Buff with Blue symbol on White ground.
House Flag Pale Blue background with Dark Blue symbol.
Trading Manchester to Liverpool.
Treated Sewage Sludge has been disposed of at sea by Manchester Corporation since 1897. The responsibility for this work was taken over by the Water Authority in 1974. There are 4 vessels in the fleet.

8 P & O Ferries 'ULSTER PRINCE'
Funnel Blue.
House Flag Diagonally - Quartered Blue, White, Red and Yellow.
Trading Ferry Routes - England to Ireland, France, Belgium, Scotland to Ireland and Northern Isles.
General Cargo, Containers, Cars and Passengers.
The Belfast Steamship Company was founded in 1852 to operate between Belfast and Liverpool and taken over by the Peninsular and Oriental Steam Navigation Co. in 1971. P & O has Royal connections going back to 1842 when one of their vessels carried Queen Victoria from Leith to London.

9 Merseyside Passenger Transport Executive 'OVERCHURCH'
Funnel Green with Black Top.
House Flag A Blue Emblem with a White Strip either side. The Emblem represents the figures 69 commemorating the year the Executive was formed, and the integration of Road and Rail Transport.
The Executive co-ordinates public transport on Merseyside and took over ferry operations from the Boroughs of Birkenhead and Wallasey.

10 The Mersey Docks & Harbour Company 'G.H.D. MERSEY 41'
Funnel Buff with Black Top.
House Flag White with Blue Wavy Diagonal and 'Liver' Bird and Star on opposite sides.
The Company took over the responsibilities of the former Dock Board in 1971 to own and control the docks at Liverpool and Birkenhead. It is a Pilotage, Conservancy and Harbour Authority and also the largest stevedoring Company in Europe.

11 The Mersey Docks & Harbour Company 'F. C. SAMSON' FLOATING CRANE
Funnel Buff with Black Top.
House Flag White with Blue Wavy Diagonal and 'Liver' Bird and Star on opposite sides.
The Company took over the responsibilities of the former Dock Board in 1971 to own and control the docks at Liverpool and Birkenhead. It is a Pilotage, Conservancy and Harbour Authority and also the largest stevedoring Company in Europe.

12 Thos. & Jas. Harrison Ltd. 'INVENTOR'
Funnel Black with One White Band between Two Red Bands. Black Top.
House Flag Red Maltese Cross on White ground.
Trading World Wide. General Cargo.
Founded in 1853, traded to Charente region of France carrying wines and brandy to Liverpool. Later expanded trade with India, South America, West Indies and South Africa. Lost 58 vessels in two World Wars. The first British Company to fit vessels with 'Stulcken' Heavy Lift Derrick. Also has fast container service to the West Indies.

13 Houlder Bros. & Co. Ltd. 'BANBURY'
Funnel Buff.
House Flag White Maltese Cross on Red Flag.
Trading U.K. to Caribbean, Panama, West Coast South America.

14 Ellerman Liners Ltd. 'CITY OF ST. ALBANS'
Funnel Buff with Black Top and White Band.
House Flag Ellerman symbol on Blue Flag surmounted by a pennant with initials of John Reeves Ellerman.
Trading World Wide. General Cargo.
Founded at the turn of the century by Sir John R. Ellerman a 19th century entrepreneur who was also interested in Brewing, Finance, Property and Newspapers. Today the Company is prominent in containerised and Roll on - Roll off shipping. It also has a stake in North Sea Oil sport operations.

15 Westminster Dredging Co. 'W.D. SEVEN SEAS'
House Flag Yellow, Blue Divided Diagonally.
Trading Dredger in River Mersey.

16 Royal Naval Reserve Vessel 'LOYAL CHANCELLOR'

17 British Transport Docks Board 'AFAN'
Funnel Blue with a White Bollard symbol.
House Flag As for funnel.
Trading Dredging Garston Channel.
The Nationalised Ports Authority established in its present form in 1963. There are 19 Ports in the group.

76

The Isle of Man Steam Packet vessel *Manxman* sails from Liverpool on her last commercial voyage for the company on 4 September 1982.

Pacific Steam Navigation's passenger vessel *Reina Del Mar* berthed astern of *Aureol* at the landing stage.

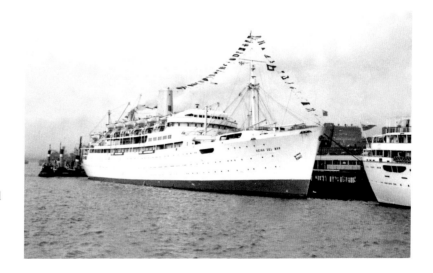

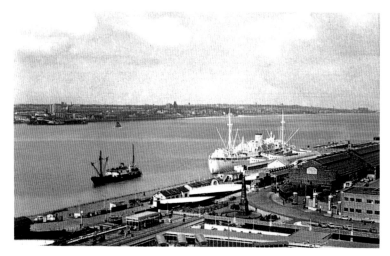

The Mersey Docks & Harbour Board salvage vessel *Salvor* passes Elder Dempster's *Accra* at the Pier Head. *Salvor* was built at Port Glasgow in 1947 and was sold for breaking up at Garston in 1978. Her masts and derricks are now preserved on the traffic island at the Pier Head.

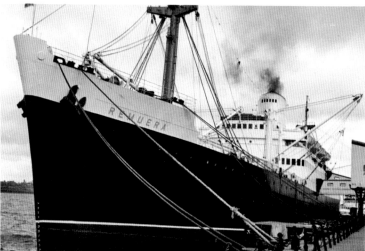

The New Zealand Shipping Company passenger liner *Remuera* sails on her first voyage for the company, from Princes Landing Stage in 1962. She was built for the Cunard Line as *Parthia* and was transferred to the Eastern & Australian Steamship Company in 1965, renamed *Aramac*, for the Melbourne to Hong Kong and Japan service. She was broken up in 1969.

The tug *Pea Cock* moves from her berth at the south end of Princes Landing Stage.

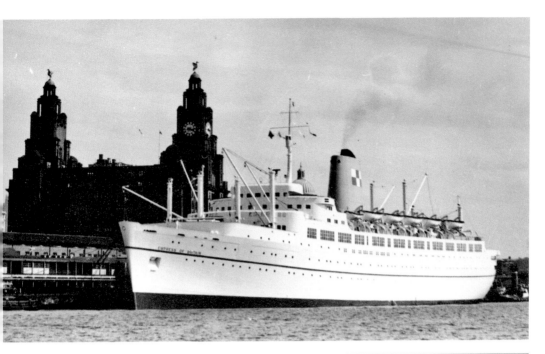

The Canadian Pacific liner
Empress of Britain at the stage.

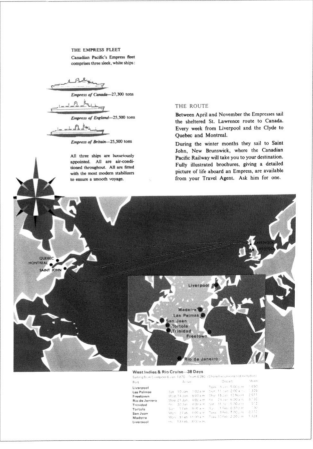

THE EMPRESS FLEET

Canadian Pacific's Empress fleet
comprises three sleek, white ships:

Empress of Canada—27,300 tons

Empress of England—25,500 tons

Empress of Britain—25,500 tons

All three ships are luxuriously
appointed. All are air-condi-
tioned throughout. All are fitted
with the most modern stabilizers
to ensure a smooth voyage.

THE ROUTE

Between April and November the Empresses sail
the sheltered St. Lawrence route to Canada.
Every week from Liverpool and the Clyde to
Quebec and Montreal.

During the winter months they sail to Saint
John, New Brunswick, where the Canadian
Pacific Railway will take you to your destination.
Fully illustrated brochures, giving a detailed
picture of life aboard an Empress, are available
from your Travel Agent. Ask him for one.

West Indies & Rio Cruise—38 Days

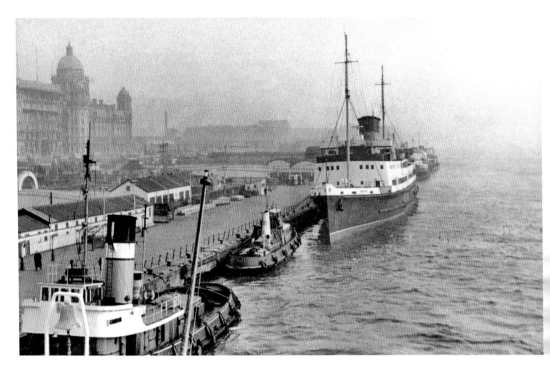

Manxman arrives from the Isle of Man, on a cold winter's day in 1964.

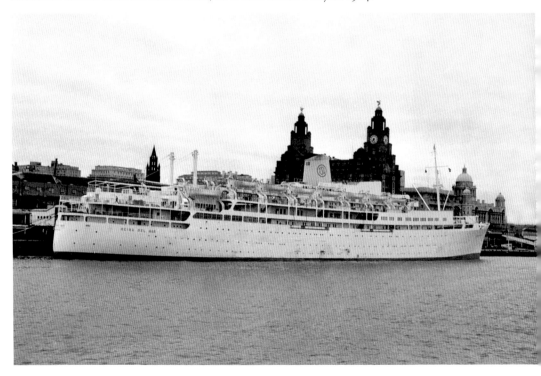

Reina Del Mar was chartered to the Travel Savings Association in 1963, and is shown in their funnel colours, prior to sailing on a Mediterranean cruise.

COASTAL CRUISING ASSOCIATION

SPECIAL SPRING CRUISE

Liverpool and North Wales

(LLANDUDNO AND MENAI BRIDGE)

SATURDAY 15th MAY 1971

by M.V. BALMORAL

Depart from						Return time
LIVERPOOL (Princes Stage)	10 00		20 30
LLANDUDNO	13 15		17 30
MENAI BRIDGE	14 30		16 00

Thence cruise passing under Menai Suspension Bridge and Britannia Railway Bridge and viewing Port Dinorwic. Cruise departs Menai Bridge 14 45 and returns 15 45.

DAY RETURN FARES:		Booked in Advance	Booked on day
From LIVERPOOL to LLANDUDNO	...	£1.50	£1.75
From LIVERPOOL to MENAI BRIDGE	...	£2.00	£2.25
From LIVERPOOL to MENAI STRAITS CRUISE	...	£2.25	£2.50
From LLANDUDNO to MENAI BRIDGE	...	80p	80p
From LLANDUDNO to MENAI STRAITS CRUISE		£1.10	£1.10
CRUISE from MENAI BRIDGE	50p	50p

Children 3-14 years half fare

Please note Special Advance Fares for tickets purchased prior to day of sailing Advance Booking strongly advised (Fares refunded if sailing cancelled)

BOOKING ARRANGEMENTS

Tickets for the cruise and meals during voyage may be purchased by post only from :—
M. R. McRONALD, 48 WELLINGTON ROAD, BIRKENHEAD, L43 2JF

Steamer tickets may also be purchased alongside the ship on 15th May (subject to availability) or in advance from :—

Above left: The Royal Liverpool Philharmonic Orchestra advert showing Liverpool Pier Head.

Above right: The Coastal Cruising Association's 'Special Spring Cruise', from Princes Stage to Llandudno and Menai Bridge, on 15 May 1971.

Below: Left to right: *Queen of the Isles, Ben My Chree* and *Empress of Canada.*

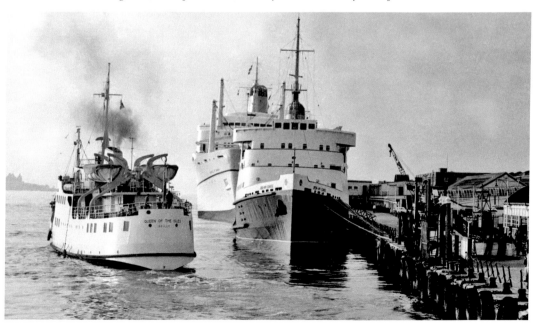

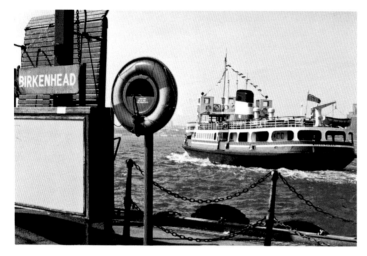

Woodchurch sails from Liverpool to Woodside.

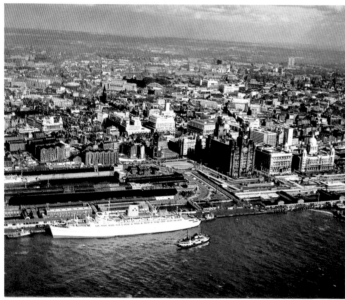

Wallasey Ferries' *Royal Daffodil* passes *Empress of England* at the Pier Head.

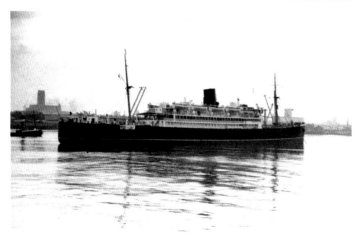

The Anchor liner *Caledonia* anchored mid-river, waiting to berth at Princes Landing Stage and load passengers for a voyage to Bombay. She was built in 1948, and completed her service with Anchor Line in 1965, when she became a floating hostel for students at Amsterdam University. She was broken up in Hamburg in 1970.

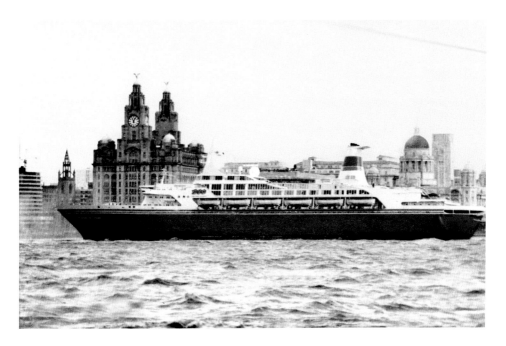

The cruise liner *Southern Cross* off the Pier Head in 1995. She was built as the *Spirit of London* for the P&O Line, and was their first vessel specially designed for cruising. *Spirit of London* sailed on her maiden voyage from Southampton to San Juan on 11 November 1972. She was renamed *Sun Princess* in 1974, becoming *Starship Majestic* and *Southern Cross* in 1995, and *Flamenco* in 1997. She was purchased by Elysian Cruises in 2004 and renamed *New Flamenco*, becoming *Flamenco 1* in 2007 when acquired by Club Cruise, and used as an accommodation ship in New Caledonia. The ship was sold at auction in Singapore in 2008 and was offered for sale in 2010.

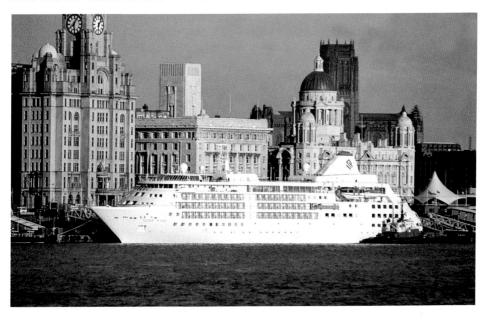

Siversea Cruises' *Silver Wind* berths at the stage.

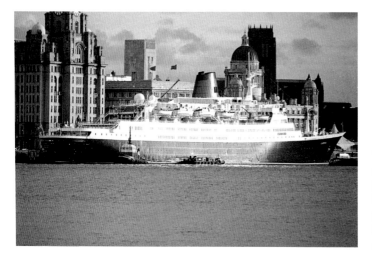

The *Vistafjord* was renamed *Caronia* at Princes Landing Stage in 1999, after she was purchased by the Cunard Line. She became *Saga Ruby* in 2005.

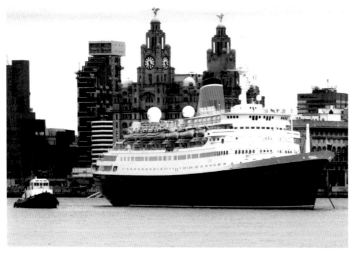

Saga Rose anchored off the Pier Head. She was built as *Sagafjord* in 1965, becoming *Gripsholm* in 1996 and *Saga Rose* in 1997. She was broken up in 2010.

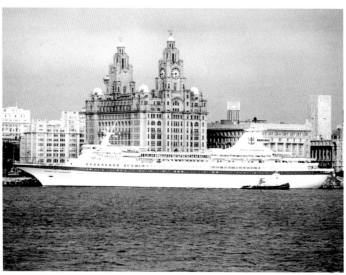

Song of Norway was built in 1970 as the first ship for the Royal Caribbean Line and was lengthened in 1978 to sail on cruises from Miami. She was sold in 1996 to Sun Cruises, part of Airtours/ My Gravel Group and renamed *Sundream*. Sold again in 2004, she became *Dream Princess*, *Clipper Pacific* in 2008, *Festival* in 2009 and *Ocean Pearl* in 2010.

The temporary landing stage at the Pier Head, for use by the Mersey ferries, which has been in use since the original stage sank in 2006. A new £7 million stage was ordered in 2010, which was due to open in 2011. The stage will sit in front of the new £10.5 million Pier Head Ferry Terminal, which houses a restaurant and Beatles attraction. The cost was partly met by European grants and partly by Merseytravel, with a contribution from Merseyside Fire & Rescue Service.

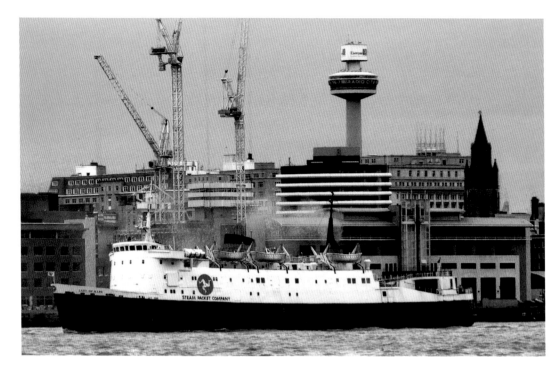

Lady of Mann leaves the stage on a voyage to Douglas, Isle of Man.

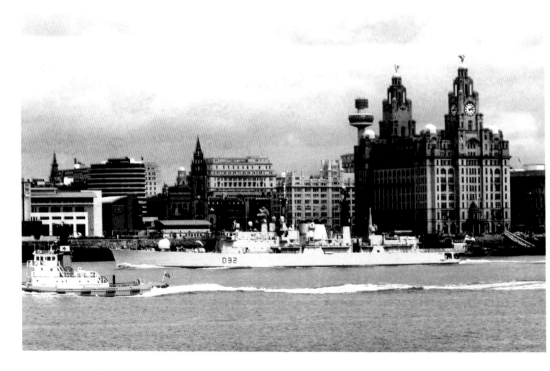

HMS *Liverpool* passes the Pier Head after a visit to the city.

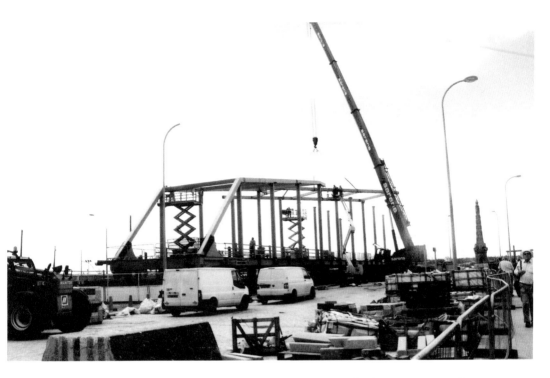

The construction of a new bridge at the Pier Head, to allow vehicles to drive onto the new Cruise Facility, and the landing stage used by the Isle of Man Steam Packet.

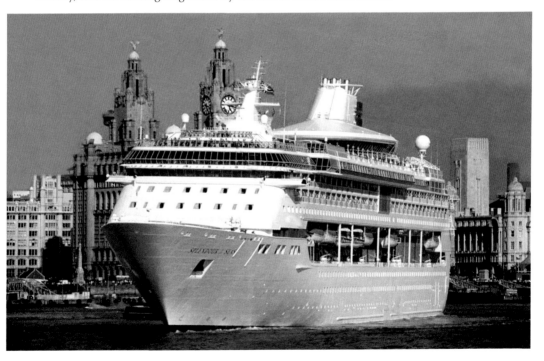

Splendour of the Seas was built by Chantiers de l'Atlantique at St Nazaire, France, and she visited the Mersey on a cruise.

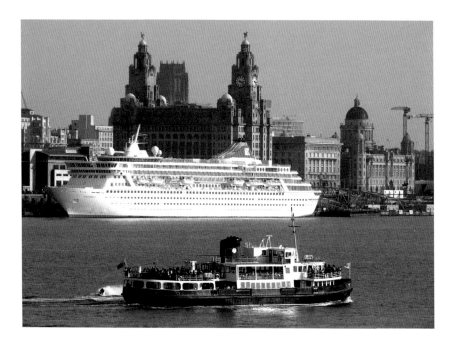

Fred Olsen's *Balmoral* was built for the Royal Cruise Line by Meyer, at Papenburg, Germany, as the *Crown Odyssey*. She became *Norwegian Crown* in 1996, and was purchased by Fred Olsen Lines in 2006. Following an overhaul in Hamburg, and the fitting of a 30 metre section, she emerged as the *Balmoral* the following year. In 2008, she was employed on Mediterranean fly cruises, and was later based at Dover for a series of cruises from the United Kingdom.

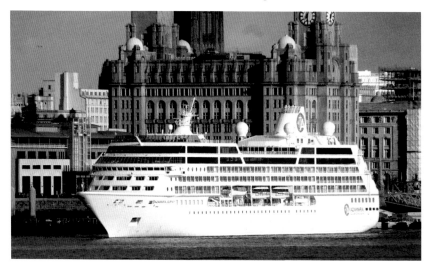

Azamara Journey was built as *R SIX* at the yard of Chantiers de l'Atlantique at St Nazaire, France, for Renaissance Cruises, which collapsed in 2001. She was one of eight sisters that were auctioned, and she was bought by Pullmantur and became *Blue Dream*. Pullmantur was bought by Royal Caribbean in 2006. It was originally planned to name her *Celebrity Journey*, but when she became a member of Azamara Cruises she received the name *Azamara Journey*.

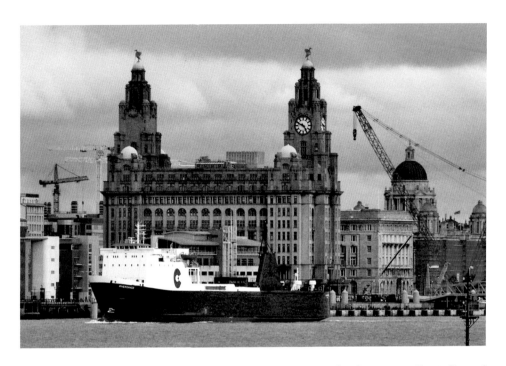

Seatruck's *Riverdance* passes the Pier Head after a major overhaul at Cammell Laird's yard in Birkenhead. She normally operated from Heysham to Ireland, but was badly damaged in a fierce storm on 31 January 2008, and went aground at Blackpool. She was later broken up on the beach.

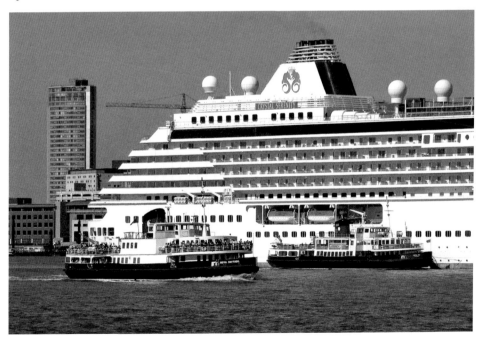

Mersey Ferries' *Royal Daffodil* and *Royal Iris* act as tenders to the *Crystal Serenity* anchored in the Mersey off the Pier Head.

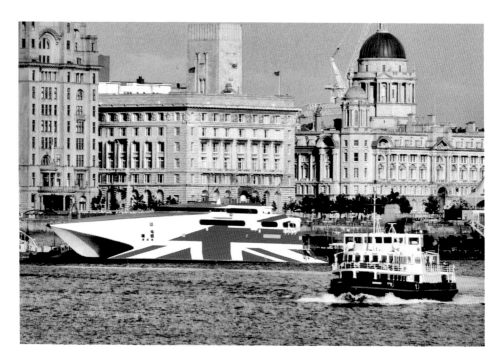

Mersey Ferries' *Snowdrop* passes *Seacat Diamant*, berthed at the landing stage.

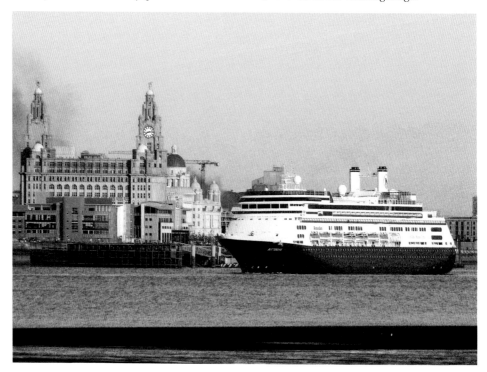

Holland America Line's *Rotterdam* pulls away from the Cruise Facility at the Pier Head. She was built by Fincantieri, in Italy, 1997, and was launched by Princess Margriet. She is the sixth Holland America vessel to bear the name.

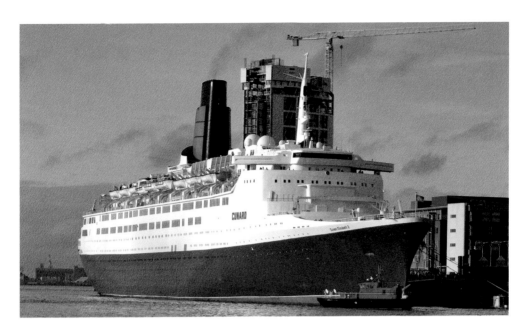

Queen Elizabeth 2 was built by John Brown & Co., on the Clyde, and was launched by Her Majesty Queen Elizabeth on 20 September 1967. She was employed on transatlantic crossings and also undertook cruises. In 1982, she participated in the Falklands Conflict and carried over 3,000 troops to the South Atlantic. She was converted from steam to diesel power in 1986/87, and the passenger accommodation was refurbished. When the line was purchased by the Carnival Corporation in 1999, the *QE2* received a $30 million dollar refurbishment. She was acquired by Nakheel on 27 November 2008 and was laid up at Port Rashid in 2011.

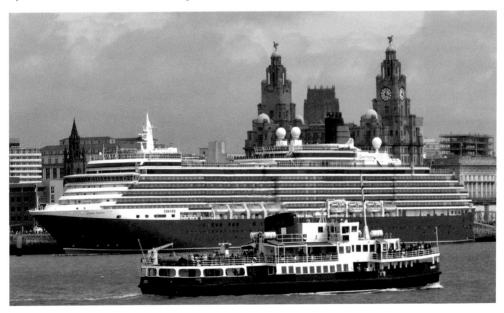

Queen Victoria berthed at the Pier Head during a Round-Britain cruise. She was built by Fincantieri, at Monfalcone, Italy. She was named by the Duchess of Cornwall in Southampton on 10 December 2007.

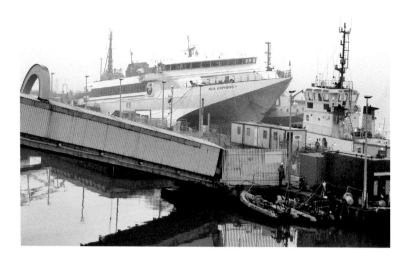

Sea Express I at the landing stage on 3 February 2007, following her collision with the *Alaska Rainbow* in thick fog off the Pier Head. The collision holed the starboard hull of *Sea Express 1*, and flooded the engine and jet pump rooms, causing her to lose power and list badly. She was towed to the landing stage by tugs, and there were no reported injuries in the incident. The official report on the collision recommended improving pilotage training and allocation of bridge duties, improving safety management systems and ensuring that safety instruction cards were appropriate. She was later towed into the wet basin at Cammell Laird, dry-docked and repaired. *Sea Express I* was renamed *Snaefell* to operate on routes in the Irish Sea.

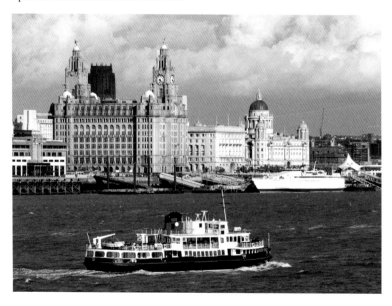

Superseacat Two in the evening sun at the Pier Head. She was built in 1997 and renamed *Viking* in 2008 by the Isle of Man Steam Packet. *Viking* was sold in 2010 to Hellenic Seaways and renamed *Hellenic Wind*.

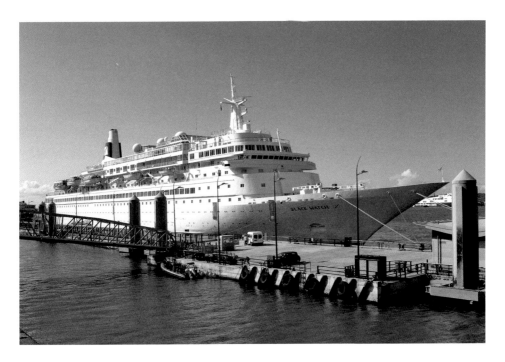

Fred Olsen's *Black Watch* at the Cruise Facility. She was built as the *Royal Viking Star* at Wartsila, Helsinki, and was lengthened at Bremerhaven in 1981. She was renamed *Westward* in 1991 and *Star Odyssey* in 1994. She was acquired by Fred Olsen in 1996, became *Black Watch*, and had her engines replaced during a major overhaul in 2005.

Regent Seven Seas Cruises' *Seven Seas Voyager* berthed at the Cruise Facility at the Pier Head.

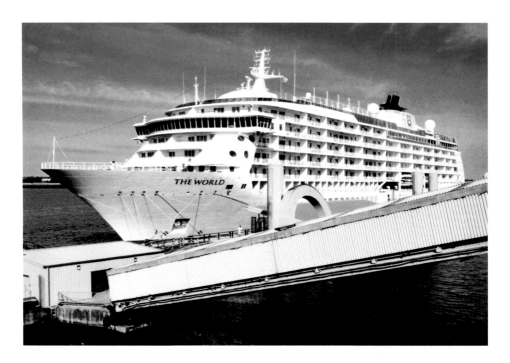

The World visited the Mersey in 2010, and berthed at the Pier Head. She is operated by Residensea and is the first luxury apartment ship where apartments are sold, with some available to rent. *The World* incorporates 106 two- and three-bedroom apartments, nineteen one- and two-bedroom studio apartments, and forty studios.

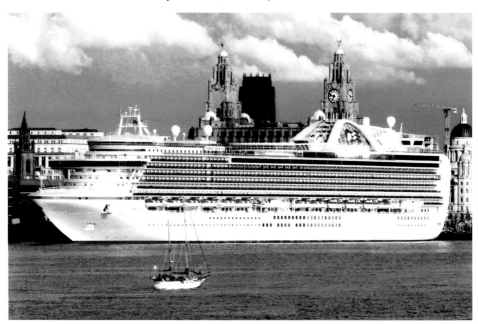

One of the largest passenger ships to enter the Mersey is the *Crown Princess*, shown berthed at the Pier Head in 2010. She was built in 2006, and is 113,651 gross tons, owned by Princess Cruises.

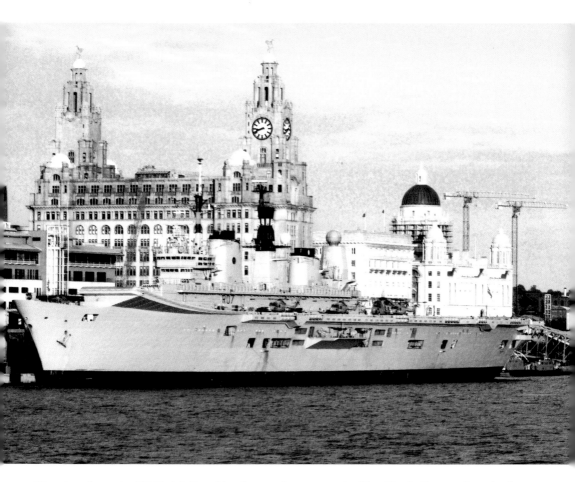

The aircraft carrier HMS *Ark Royal* in the evening sun at the Pier Head. She was launched on 2 June 1981 by Her Majesty Queen Elizabeth, the Queen Mother, at Swan Hunters' yard on the Tyne. HMS *Ark Royal* was commissioned on 1 November 1985 and was deployed in the Adriatic in 1993 during the Bosnian War. She was refitted at Rosyth in 1999, and when she was re-commissioned in 2001, she sailed to the Persian Gulf and took part in the invasion of Iraq in 2003. Following another refit, she returned to Portsmouth in 2006 and was then used as a landing platform helicopter, replacing HMS *Ocean*, while she undertook a refit. She became fleet flagship in 2007 and participated in Exercise Joint Warrior 08-02, in 2008. She assisted stranded travellers following the volcanic eruption in Iceland in 2010, and in October that year it was announced that she was to be decommissioned. She was visited by Her Majesty the Queen on 5 November 2010 at Portsmouth, before sailing to Loch Long for removal of her munitions. She was officially decommissioned at Portsmouth on 11 March 2011.

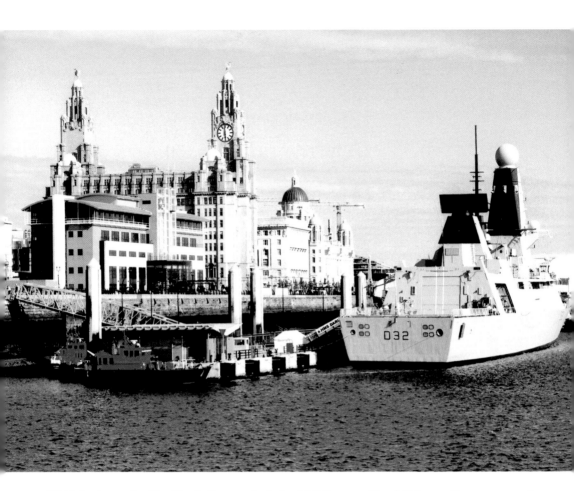

HMS *Daring* at the Pier Head. She was built by BAE Systems Naval Ships, at Scotstoun, on the Clyde, and was commissioned on 23 July 2009. She is the lead ship of the Type 45, or 'D' Class, and the seventh ship to hold the name. She is powered by two Rolls Royce WR-21 gas turbines and Alstom electric motors, which give her a speed in excess of 29 knots. She has a range of 7,000 nautical miles and a complement of 195 people.